UNICORNS ARE JERKS
a coloring book exposing
the cold, hard, sparkly truth

drawn and written by
Theo Nicole Lorenz

sourcebooks

Published by Sourcebooks, Inc.
P.O. Box 4410, Naperville, Illinois 60567-4410
(630) 961-3900
Fax: (630) 961-2168
www.sourcebooks.com

This book contains material originally published as *Unicorns Are Jerks* in 2012, *Dinosaurs with Jobs* in 2013, and *Mer World Problems* in 2014 in the United States by Theo Nicole Lorenz with the CreateSpace Independent Publishing Platform.

Printed and bound in the United States of America.
VP 10 9 8 7 6 5 4 3 2 1

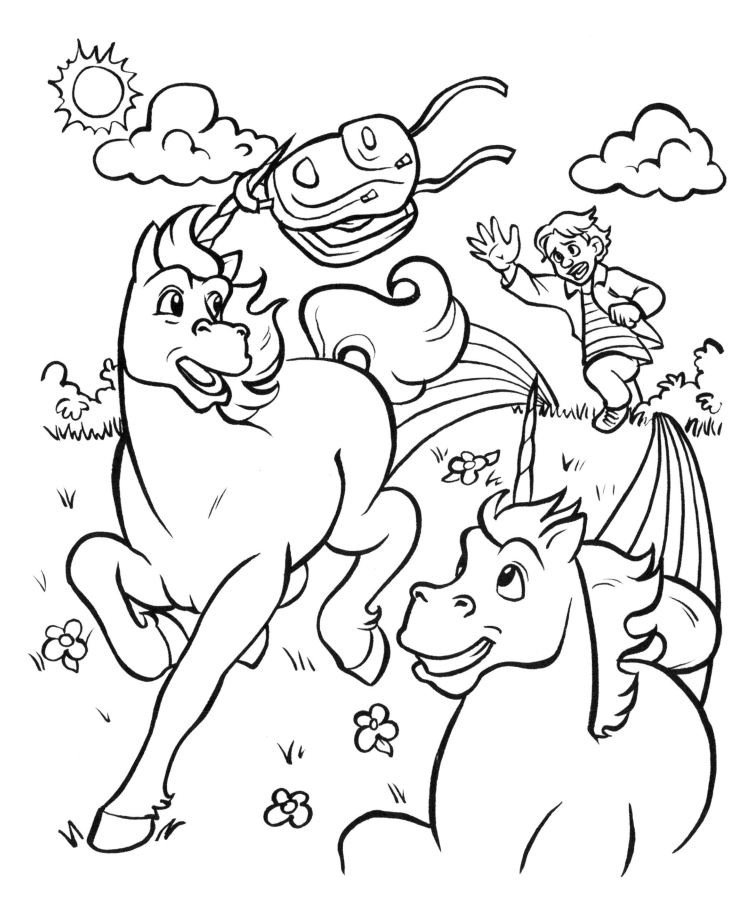

Everyone thinks unicorns are pure and magical,
but really they're jerks.

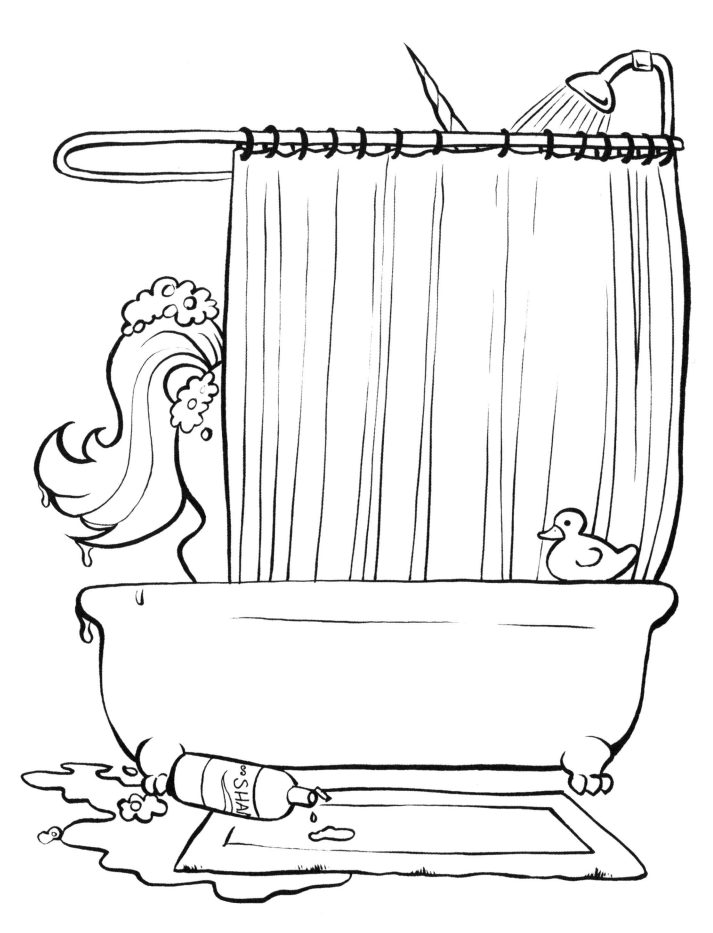

Unicorns use up all of your shampoo.

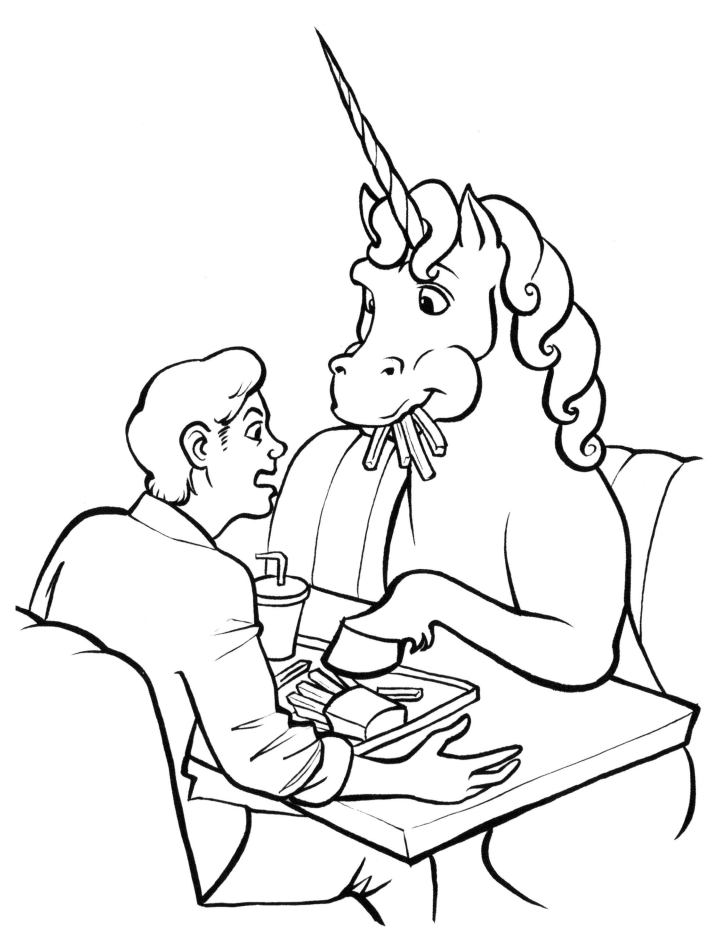

Unicorns hog your fries.

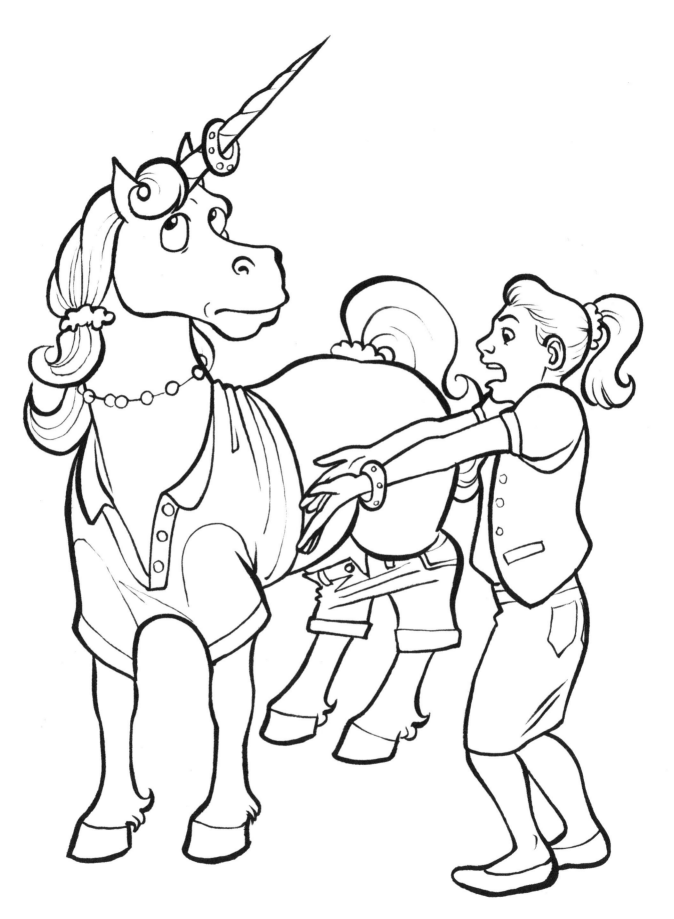

Unicorns borrow your clothes without asking permission
and stretch them out.

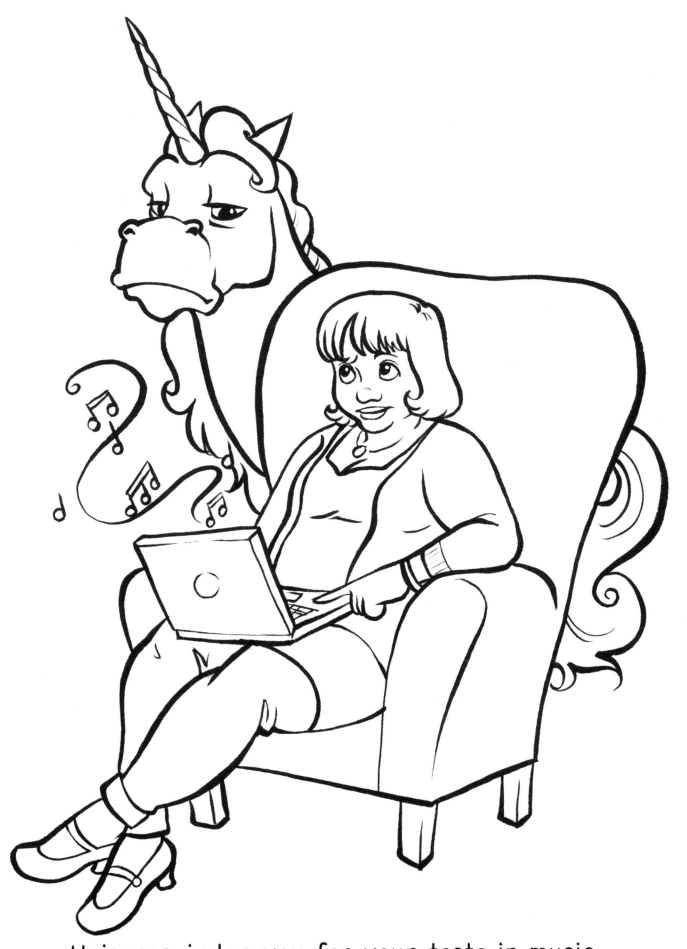

Unicorns judge you for your taste in music.

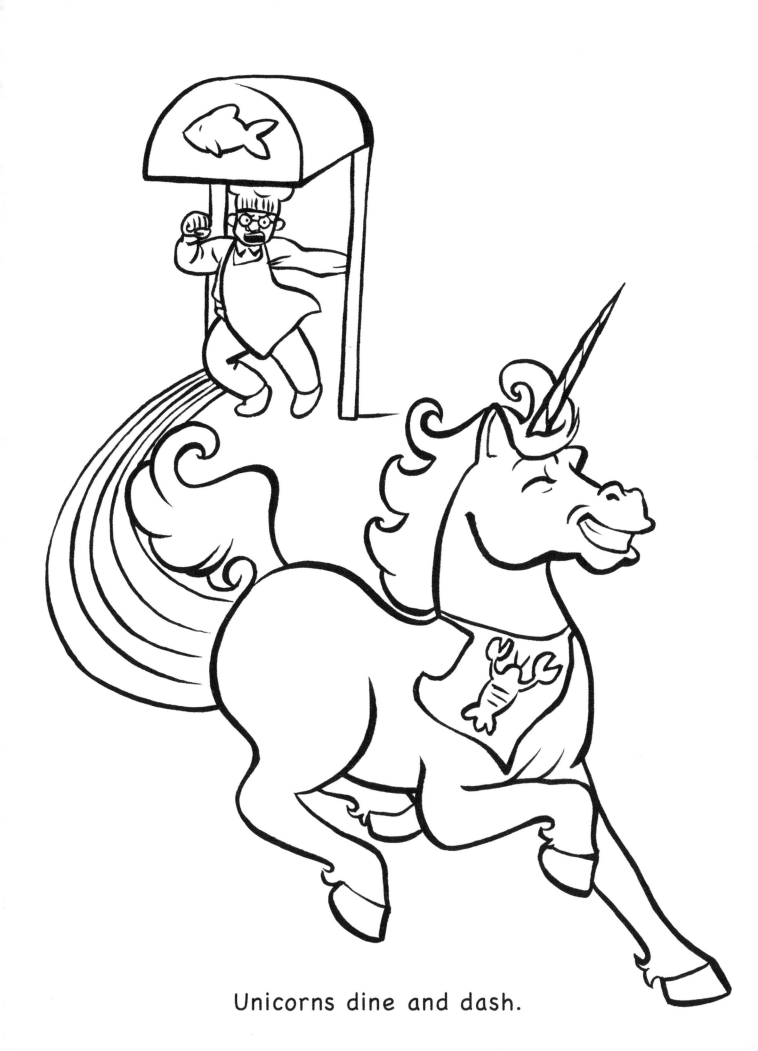

Unicorns dine and dash.

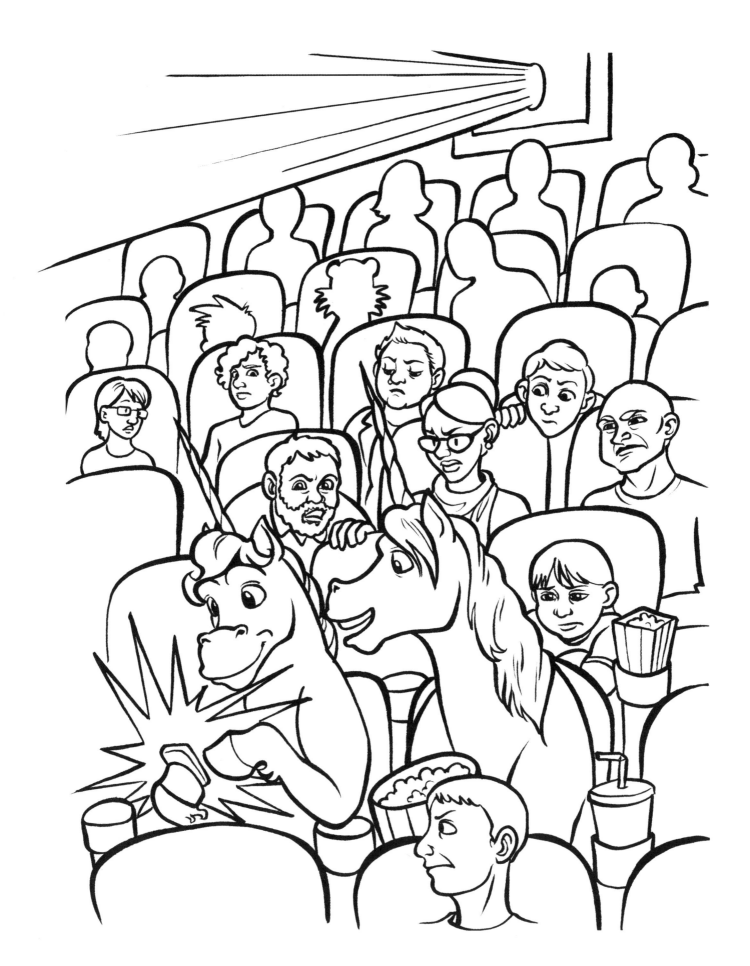

Unicorns talk and text in movie theaters.

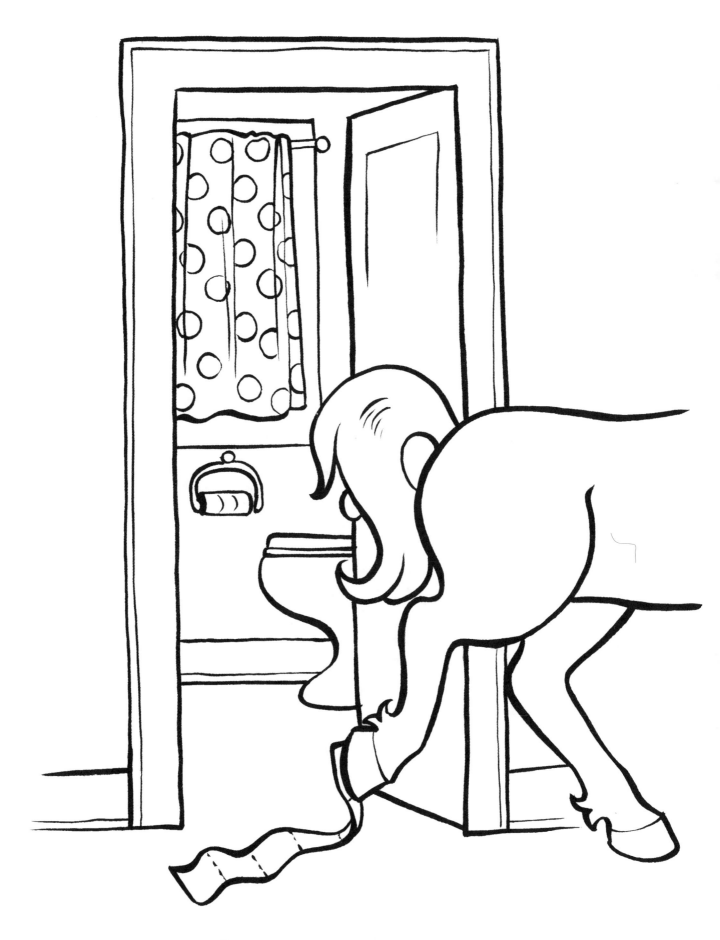

Unicorns don't replace the toilet paper roll.

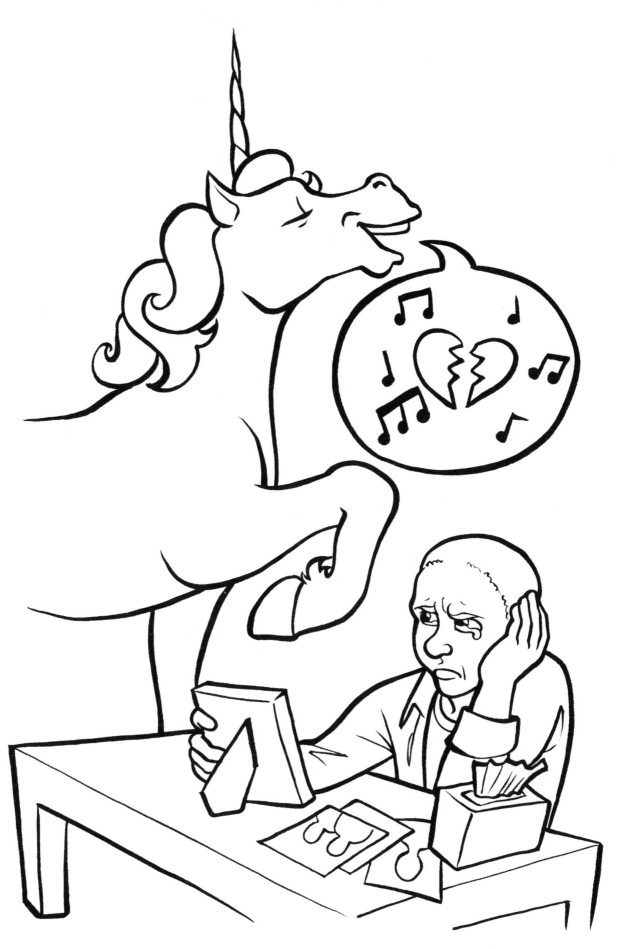

Unicorns sing breakup songs around you
when you've just been dumped.

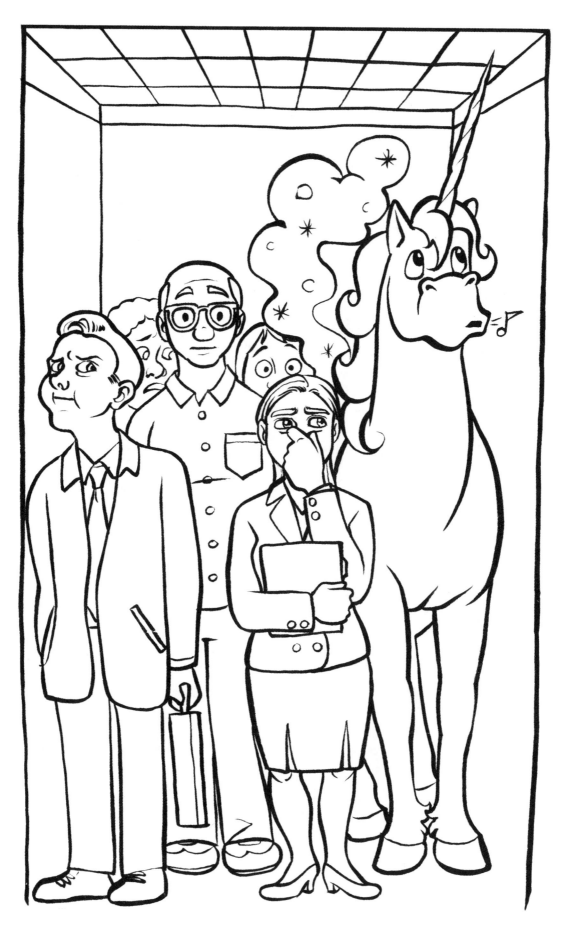

Unicorns fart in elevators.
On purpose.

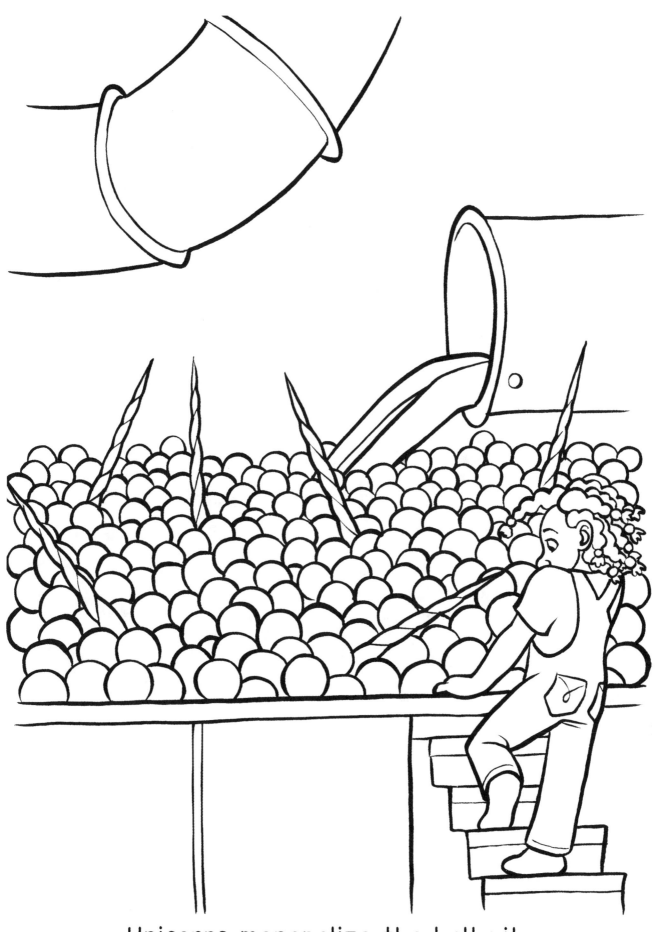

Unicorns monopolize the ball pit
and don't let anyone else in.

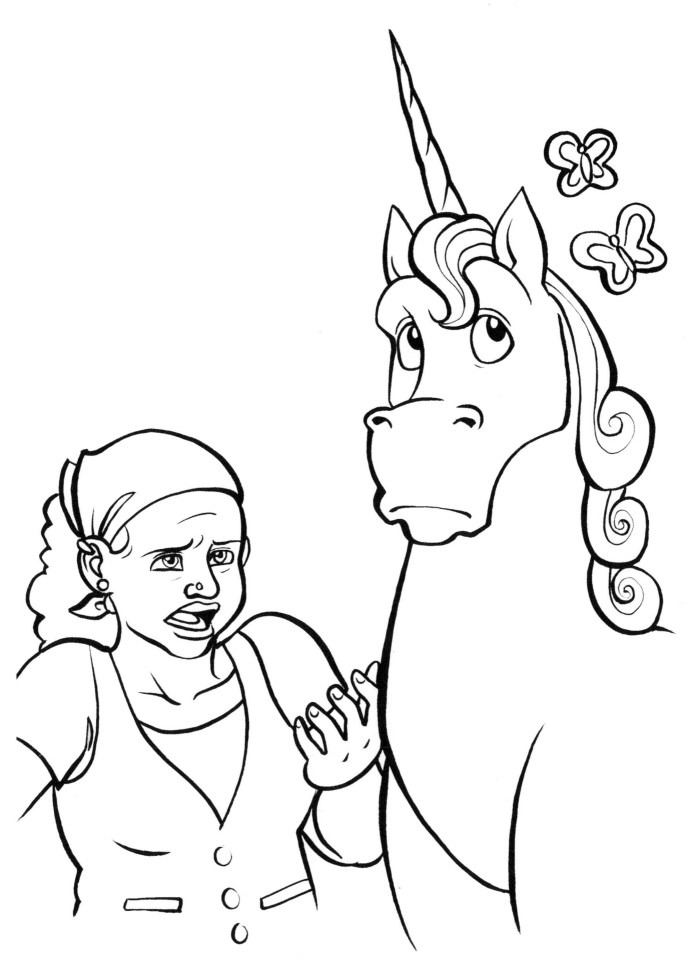

Unicorns never listen.

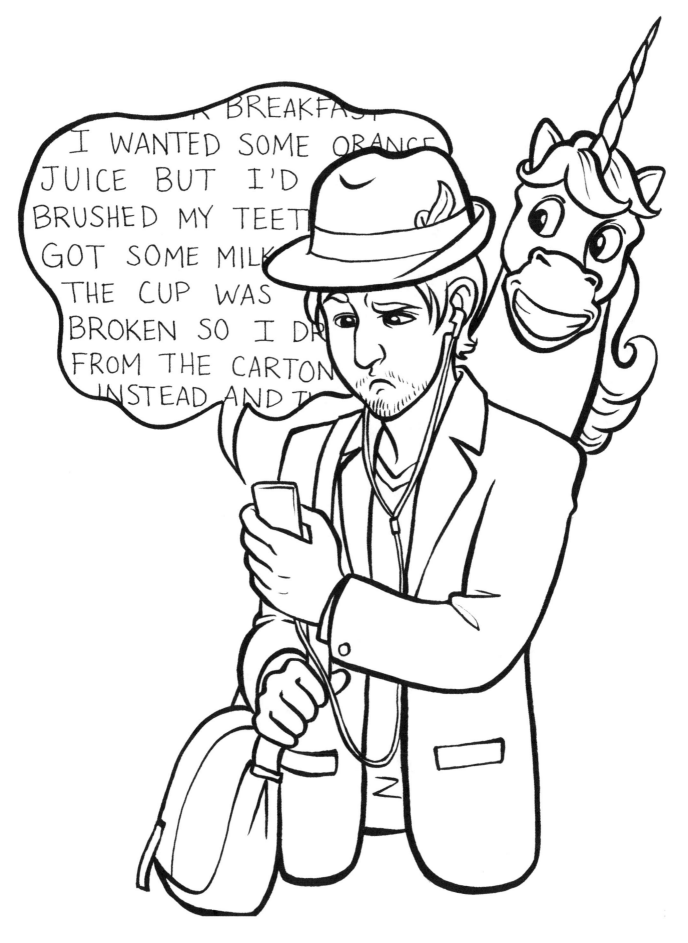

Unicorns delete your music collection
and replace it with their own audio memoirs.

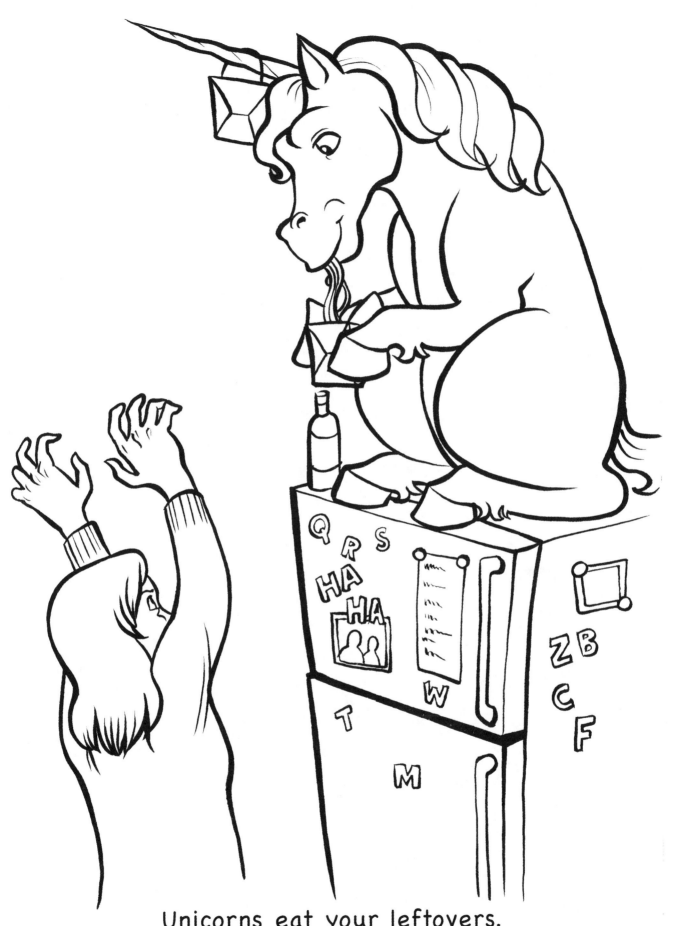

Unicorns eat your leftovers.
YOU WERE SAVING THAT!

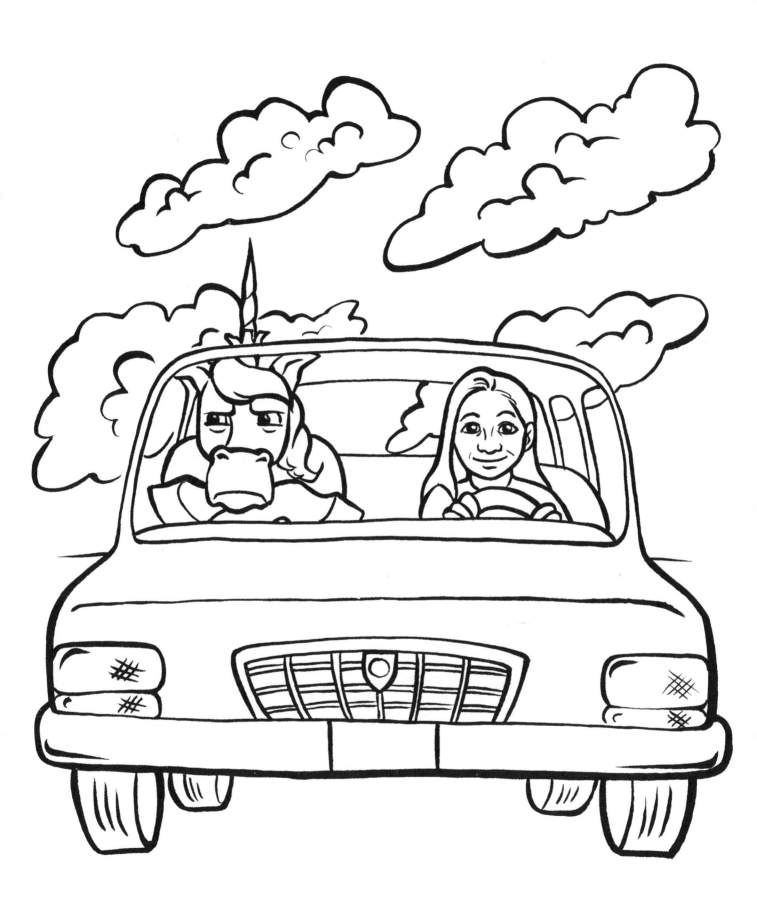

Unicorns spend the whole trip sulking
because you wouldn't let them drive.

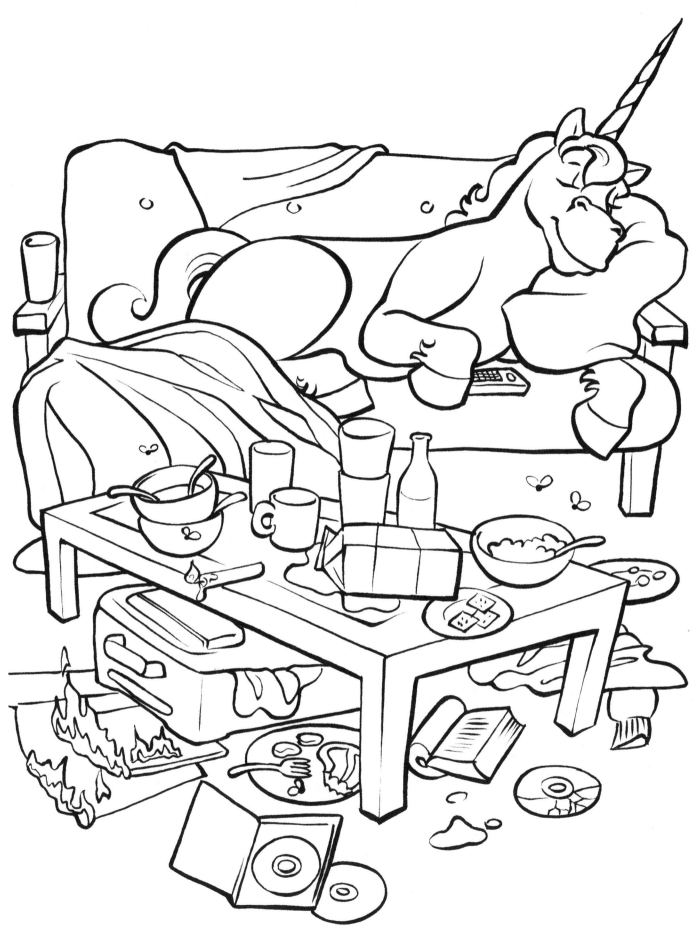

Unicorns are the worst house guests,
and they never leave.

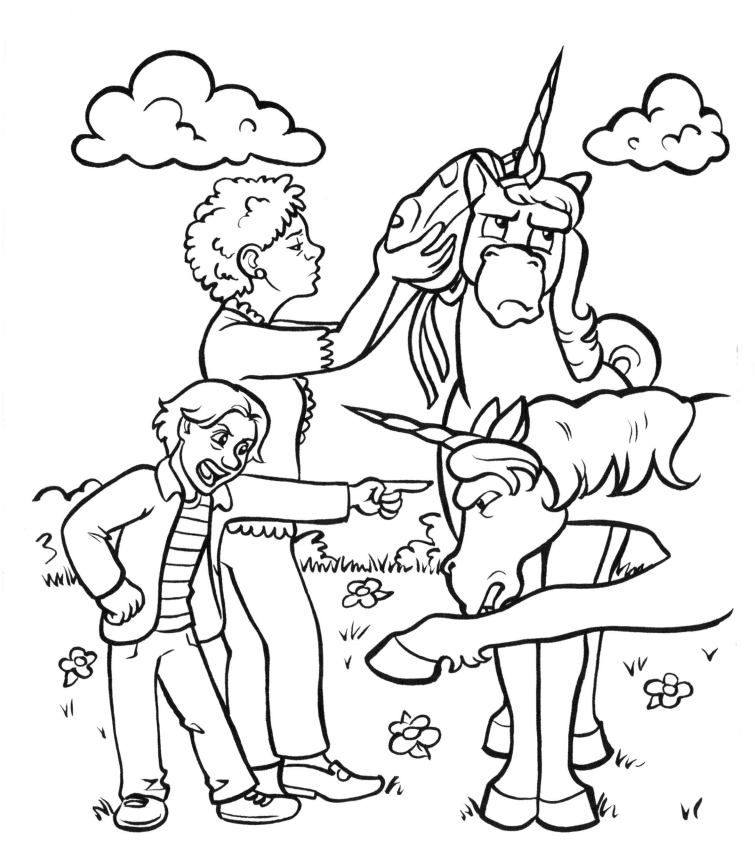

When you point out that unicorns are being jerks,
they act like YOU'RE the jerk.

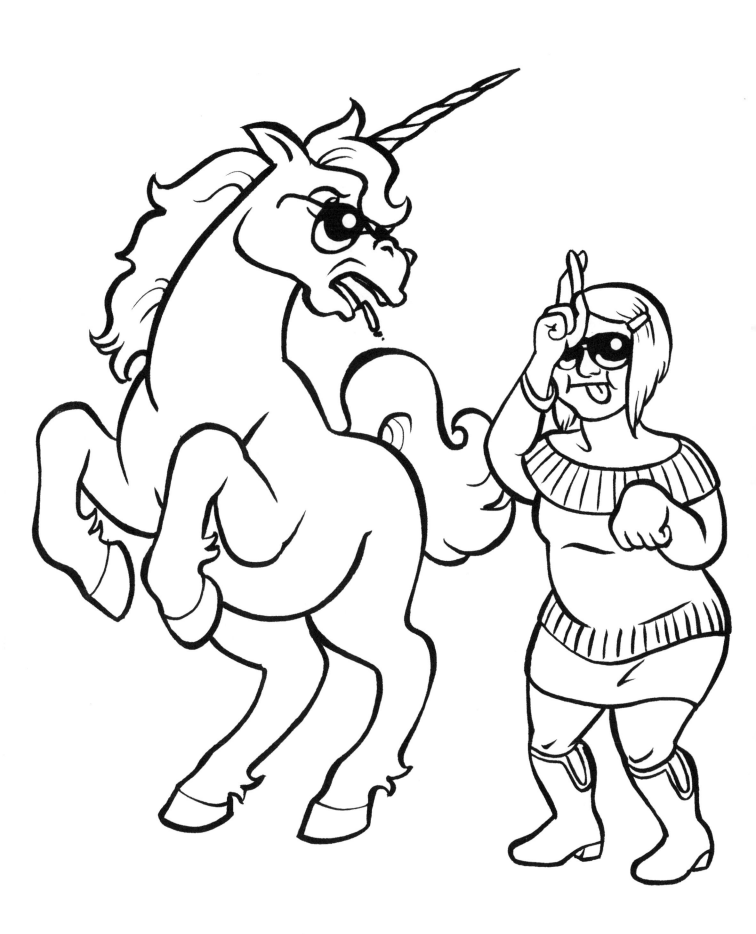

Don't be a unicorn.
Even unicorns don't appreciate it.

DINOSAURS WITH JOBS
a coloring book celebrating our
old-school coworkers

drawn and written by
Theo Nicole Lorenz

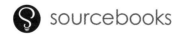 sourcebooks

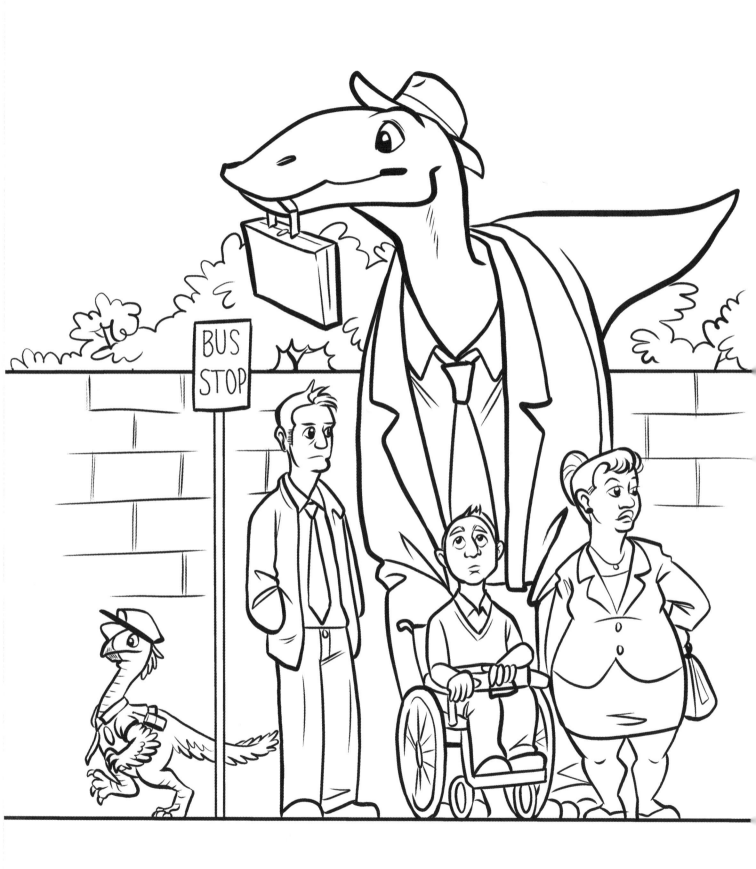

Dinosaurs are an important part of our workforce.

Stegosaurus works in a clothing store and enjoys being helpful.

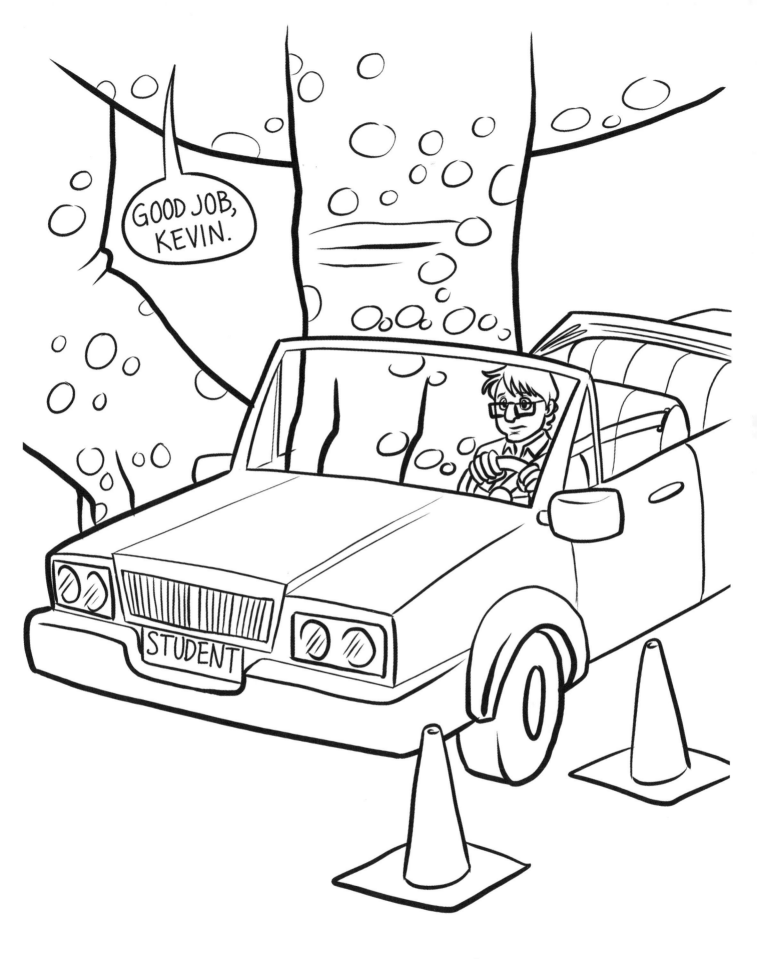

Argentinosaurus is one of the world's largest dinosaurs and the world's largest driving instructor.

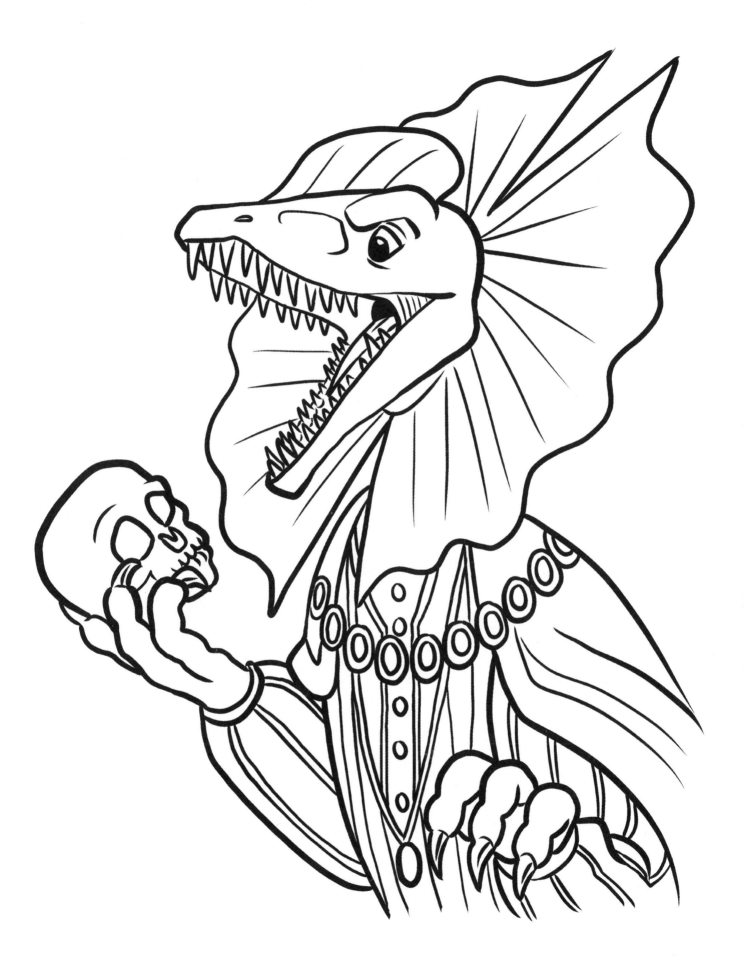

Dilophosaurus is a classically trained Shakespearean actor.

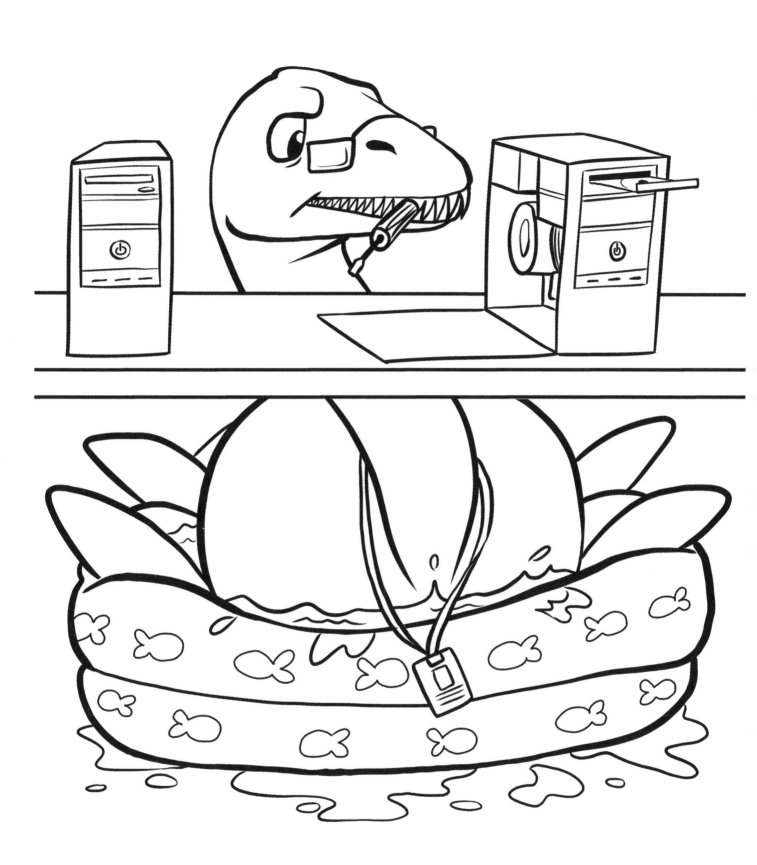

Plesiosaurus tech support specialist would like to remind you that the CD drive is NOT a cup holder.

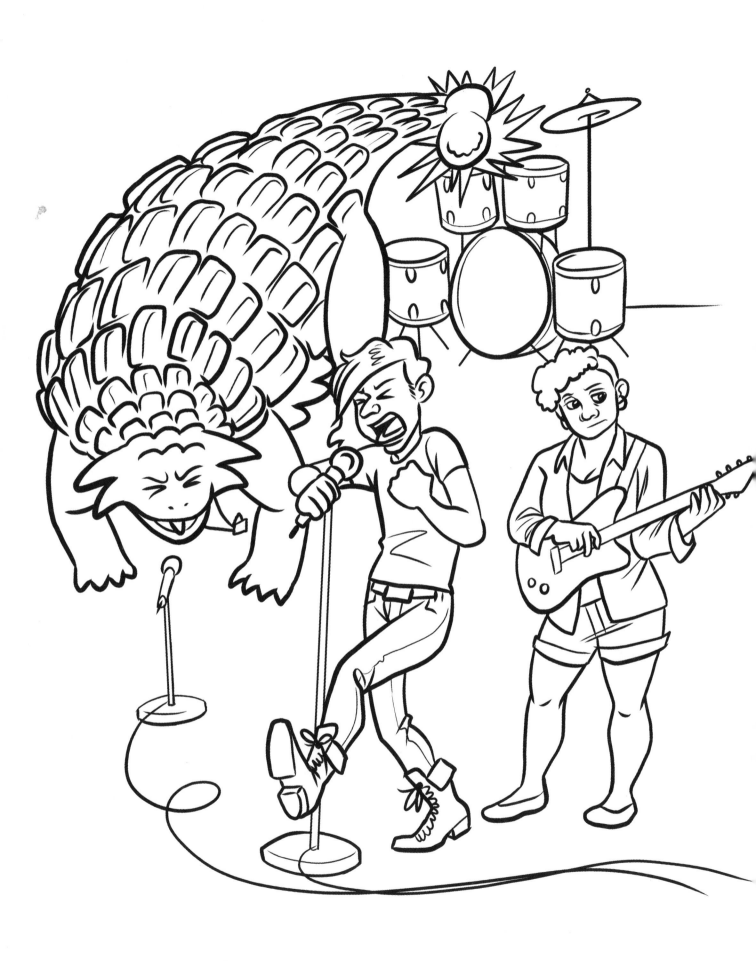

Ankylosaurus's band is going to make it big any day now.

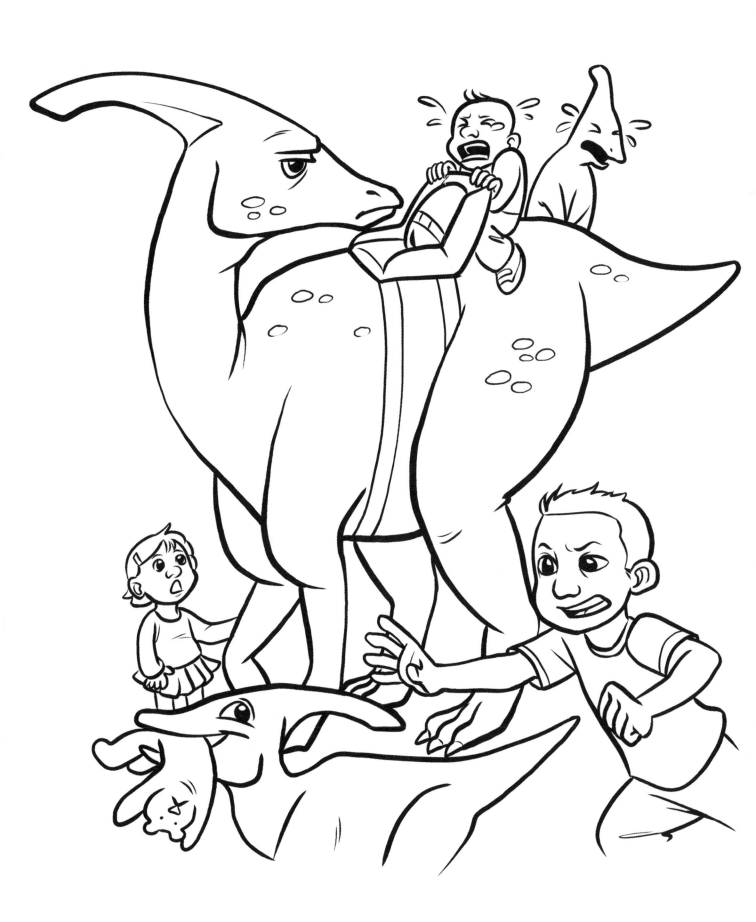

Being a stay-at-home parent is rewarding,
but Parasaurolophus wishes it came with paid time off.

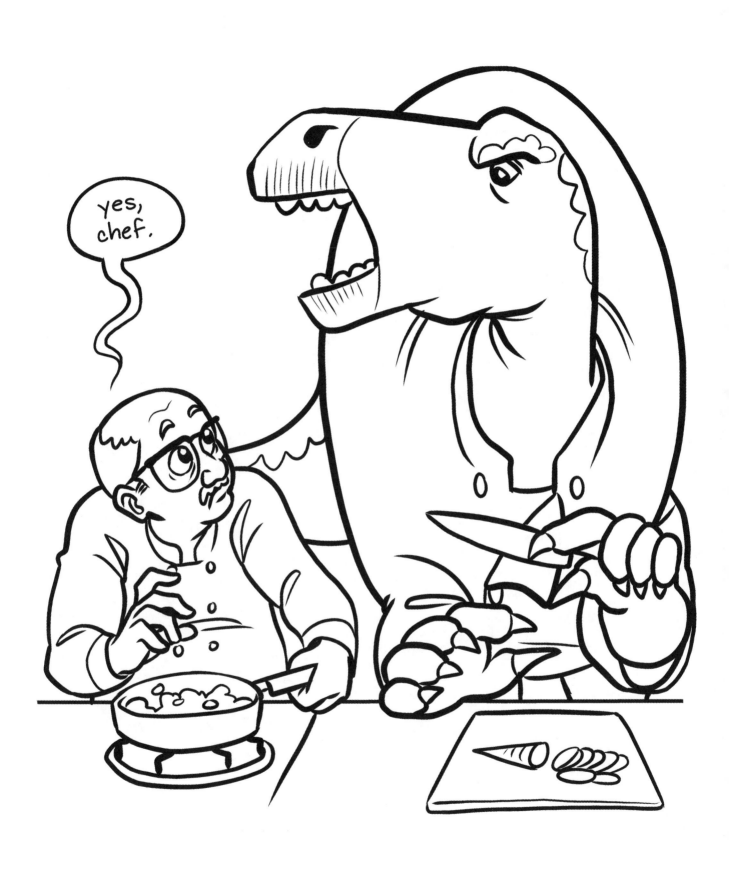

Iguanodon is a celebrity chef with his own reality TV show.

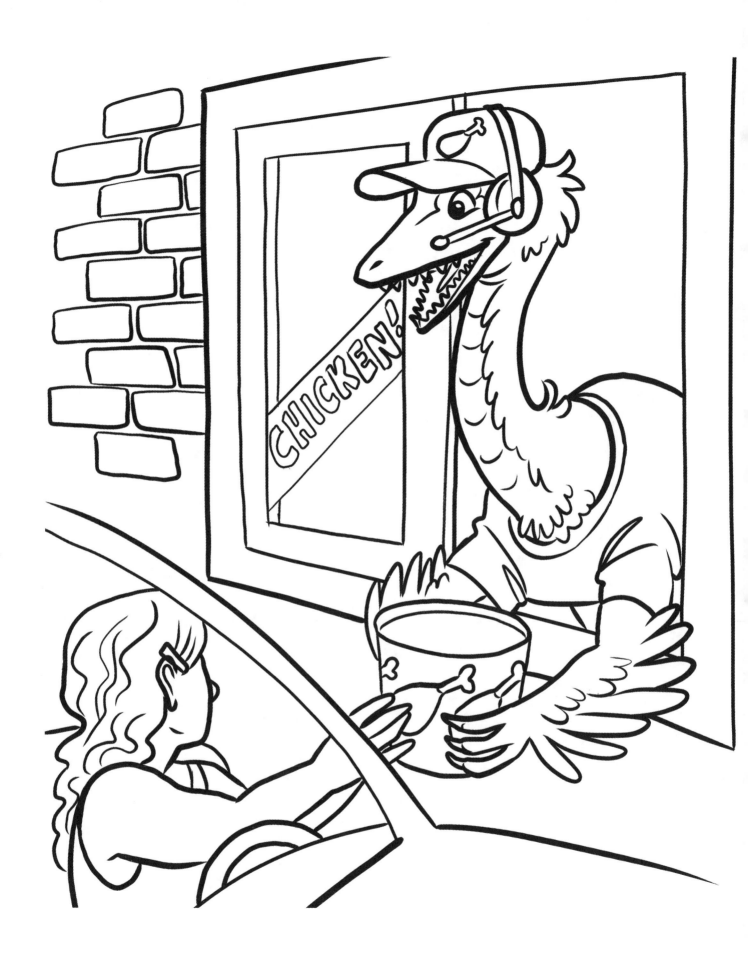

Ornithomimus works the drive-through window
and gets all the fried chicken she can eat.

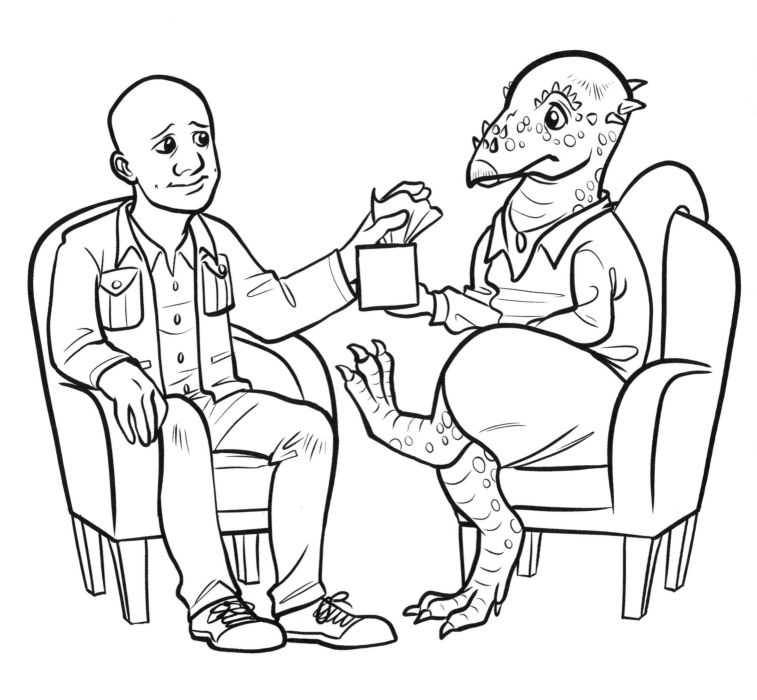

Pachycephalosaurus uses empathy instead of head-butting
to help clients at her therapy practice.

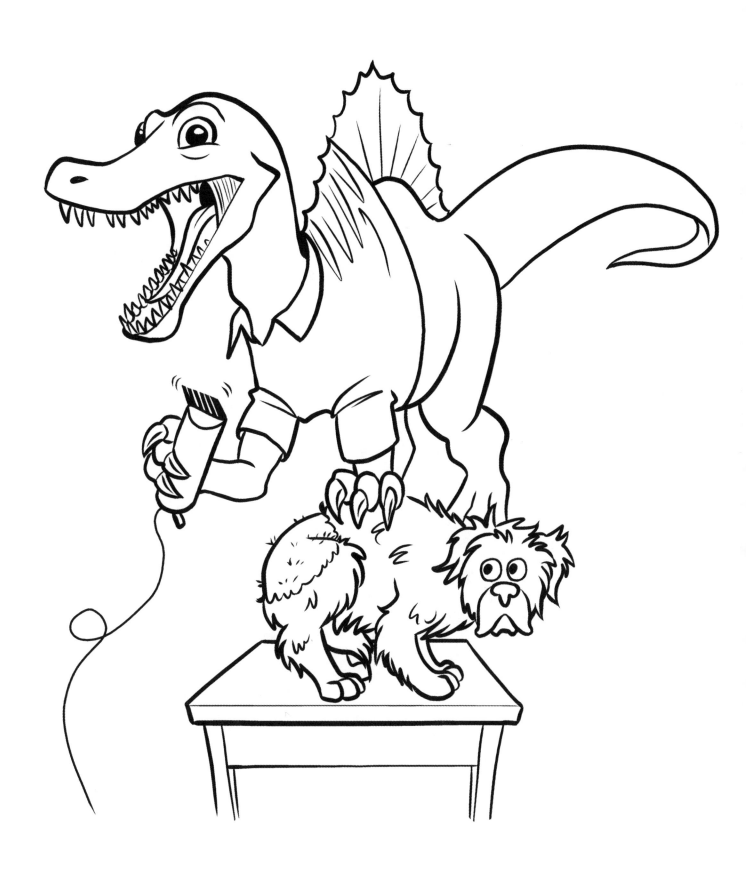

Spinosaurus loves working with animals
at the pet grooming shop!

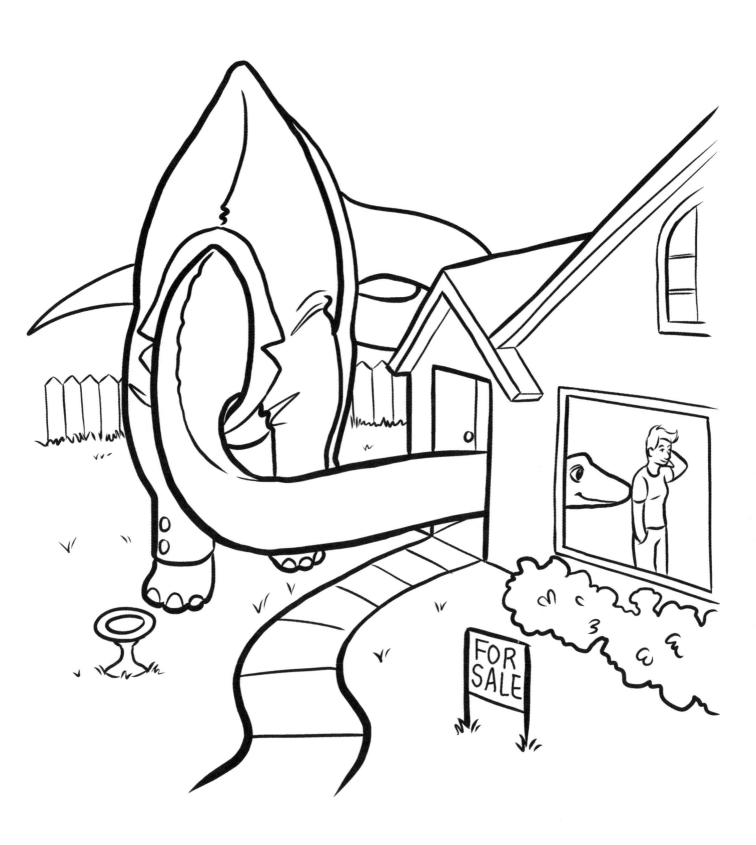

Despite the fact that she can't actually fit inside a house,
Apatosaurus is one of the top real estate agents in the area.

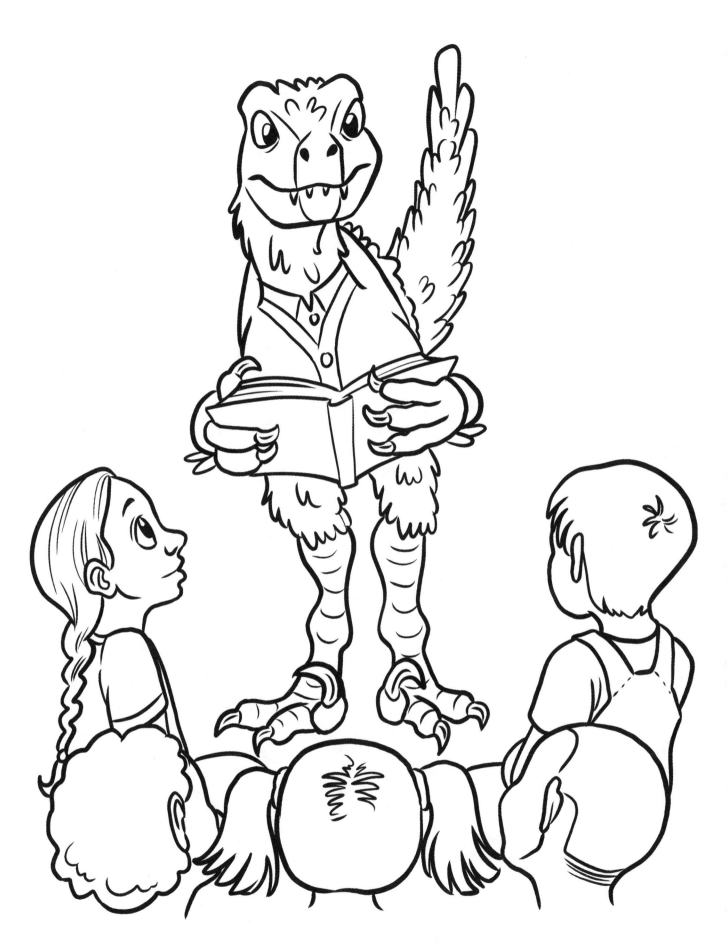

Velociraptor teaches the most well-behaved kindergarten class this school has ever seen.

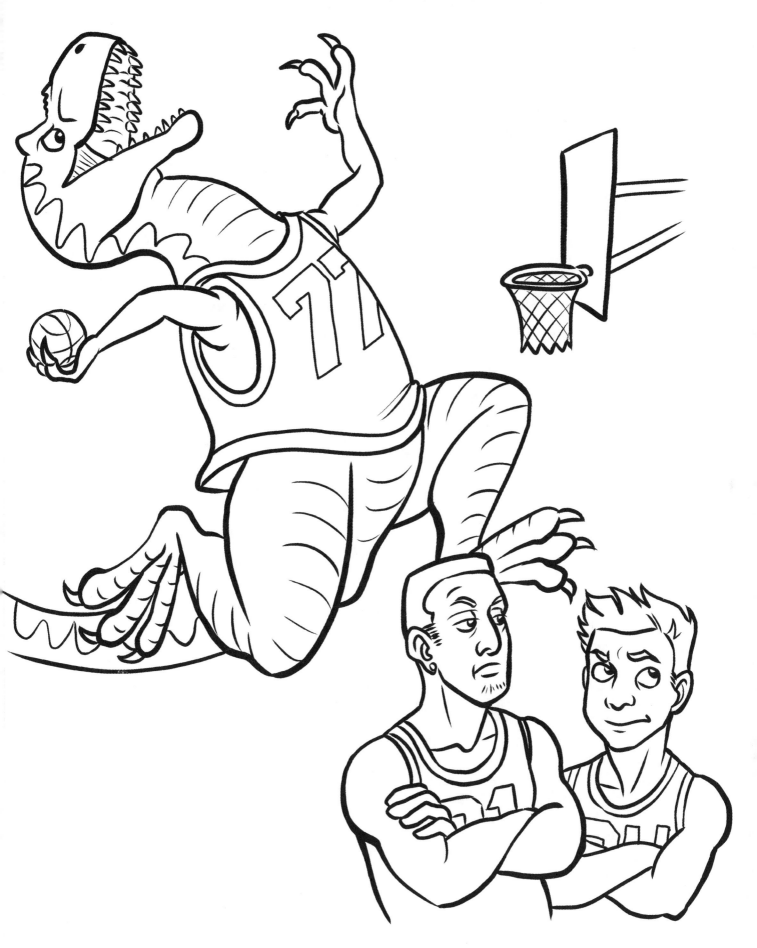

Allosaurus has been even more of a show-off since he landed his big pro basketball contract.

Compsognathus channeled his enthusiasm and flair
into a career as a wedding planner.

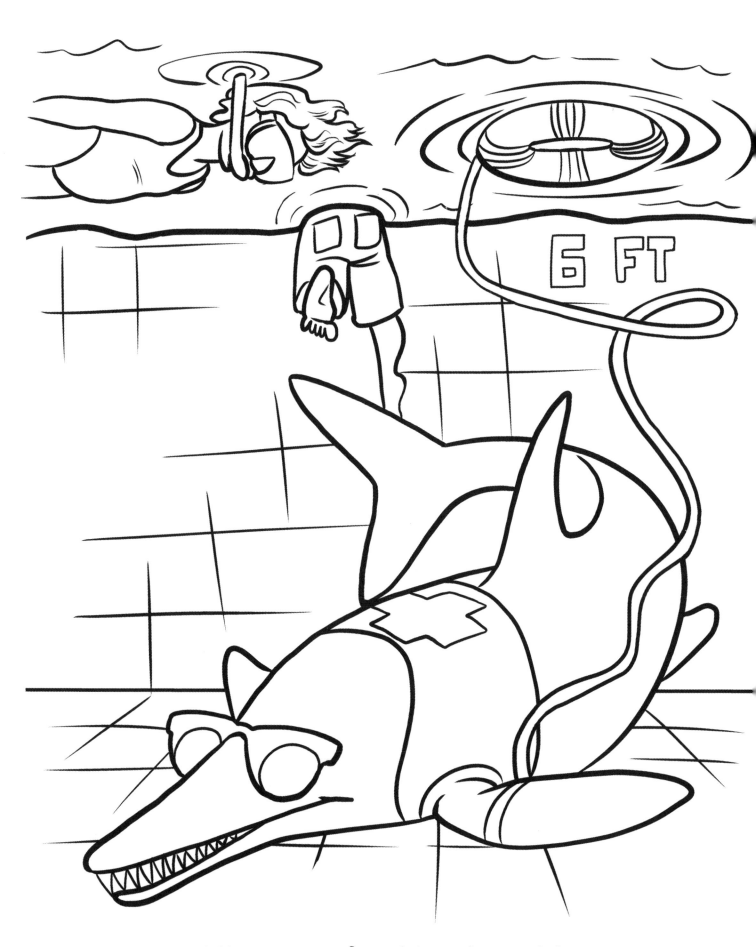

Ichthyosaurus found her dream job:
working as a lifeguard at the local pool.

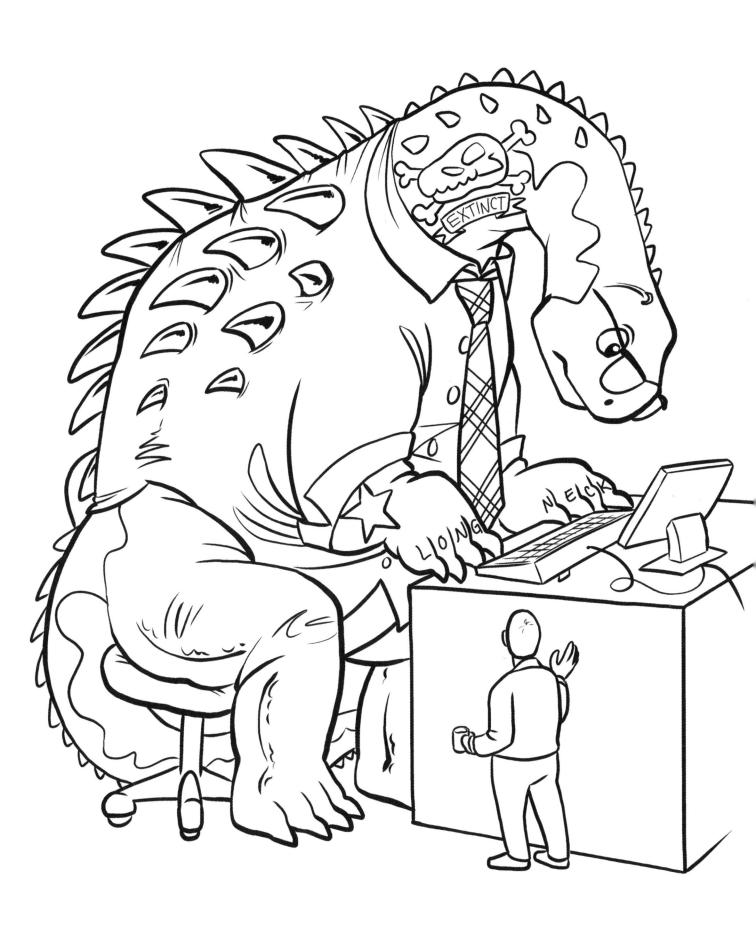

Ampelosaurus balances a career in accounting
with a punk rock lifestyle.

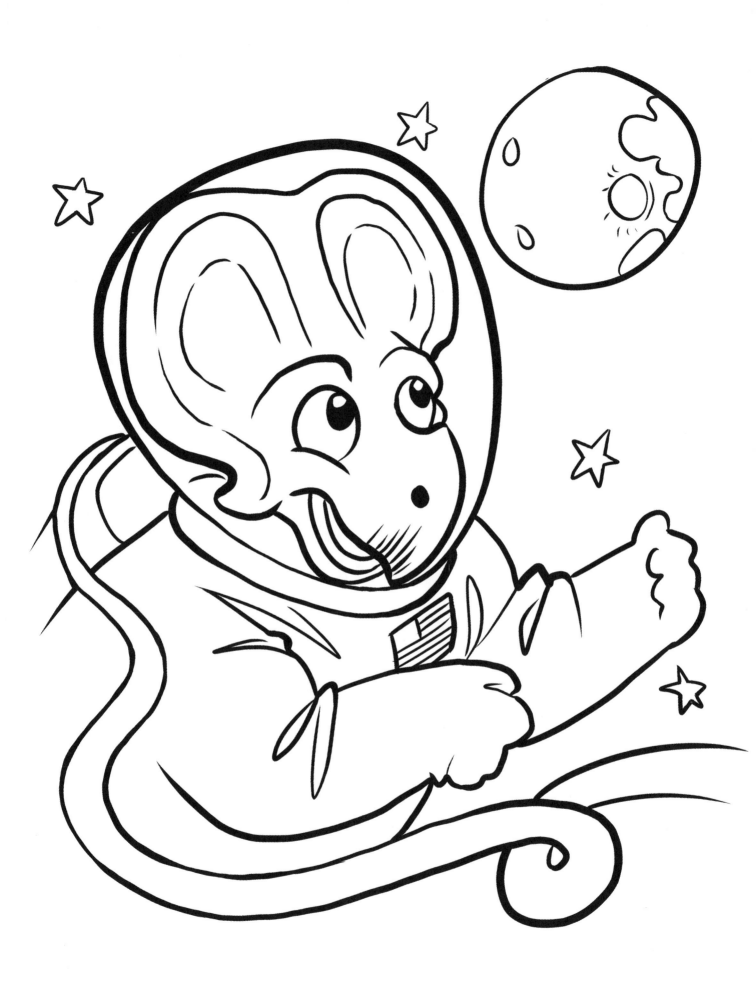

Protoceratops is the first Cretaceous creature in space!

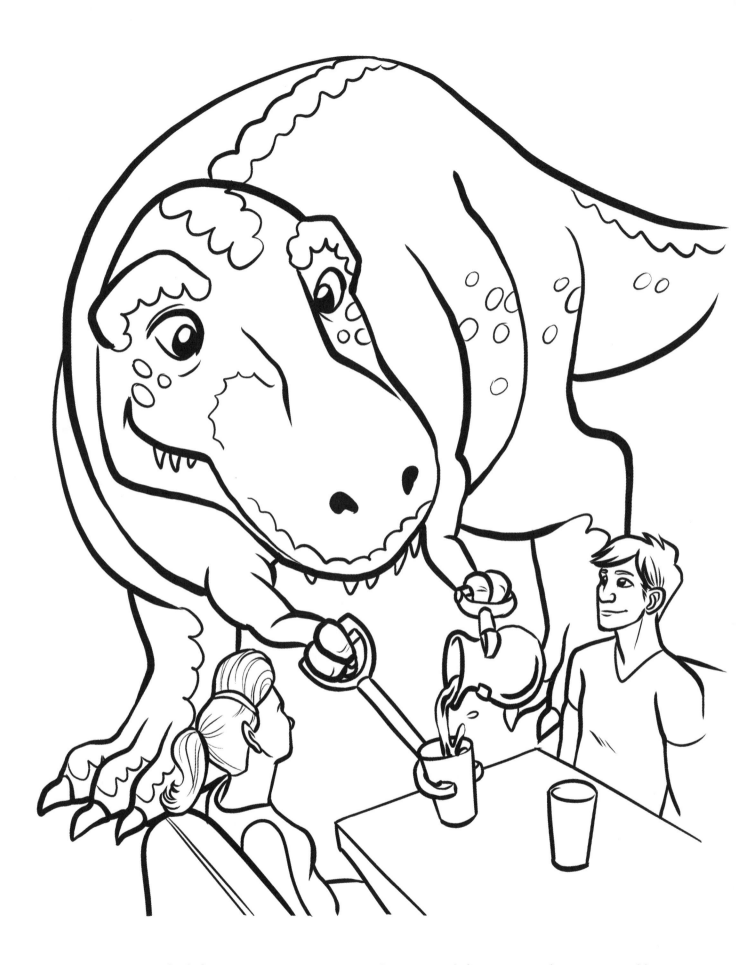

Everyone told Tyrannosaurus he could never be a waiter because of his little arms, but he makes it work.

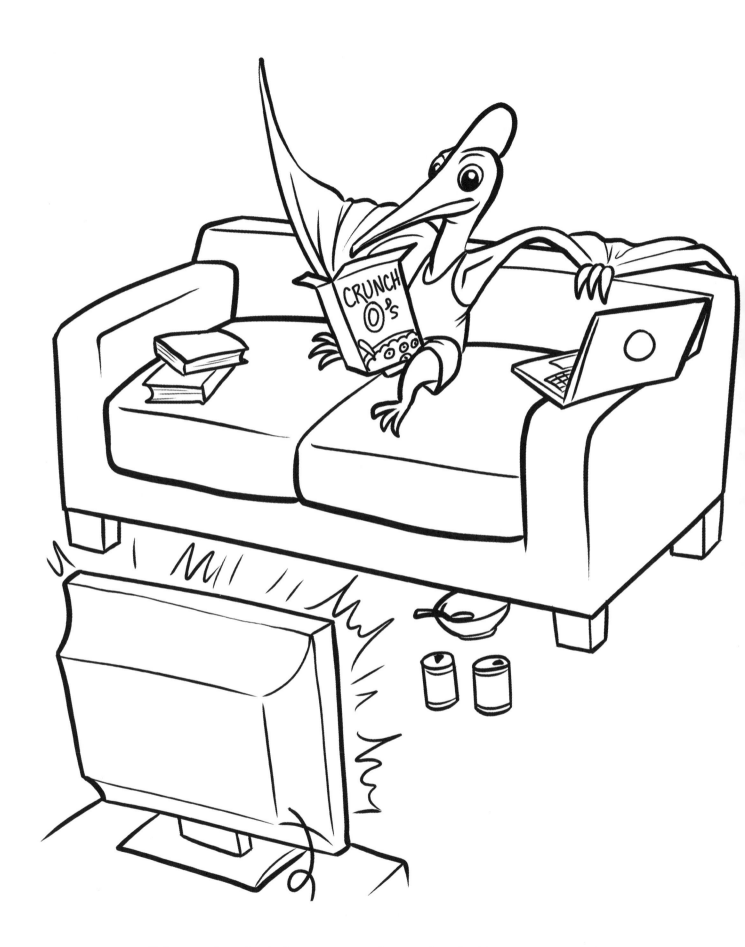

Pterodactyl is unemployed at the moment,
so she's applying for jobs and watching crime dramas.

MER WORLD PROBLEMS
a coloring book documenting
hardships under the sea

drawn and written by
Theo Nicole Lorenz

 sourcebooks

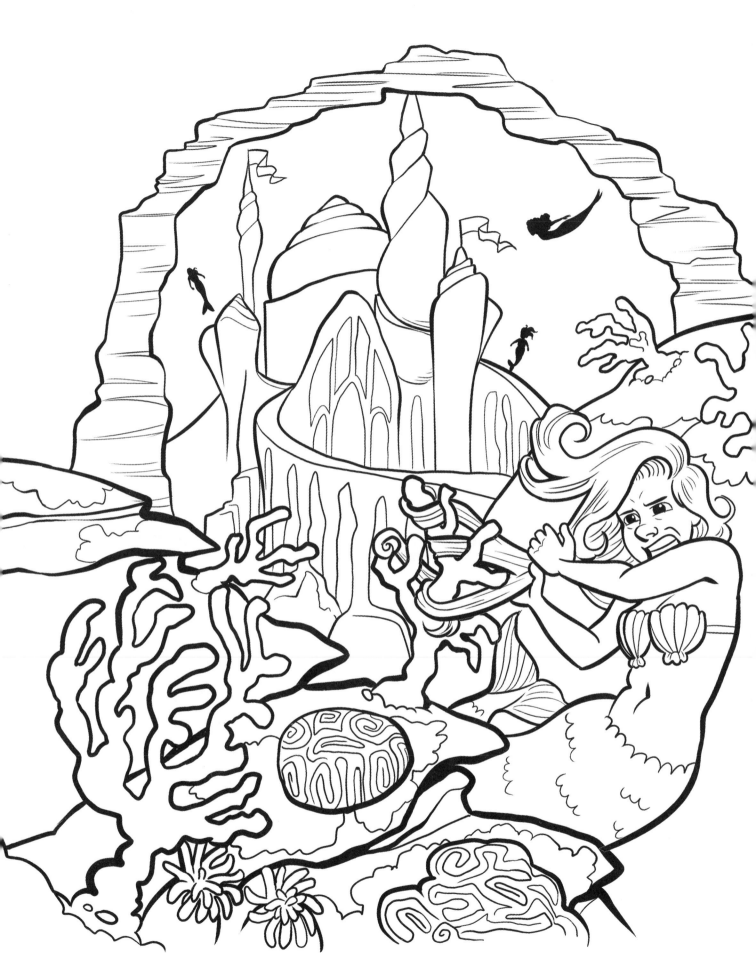

Life under the sea isn't always easy.

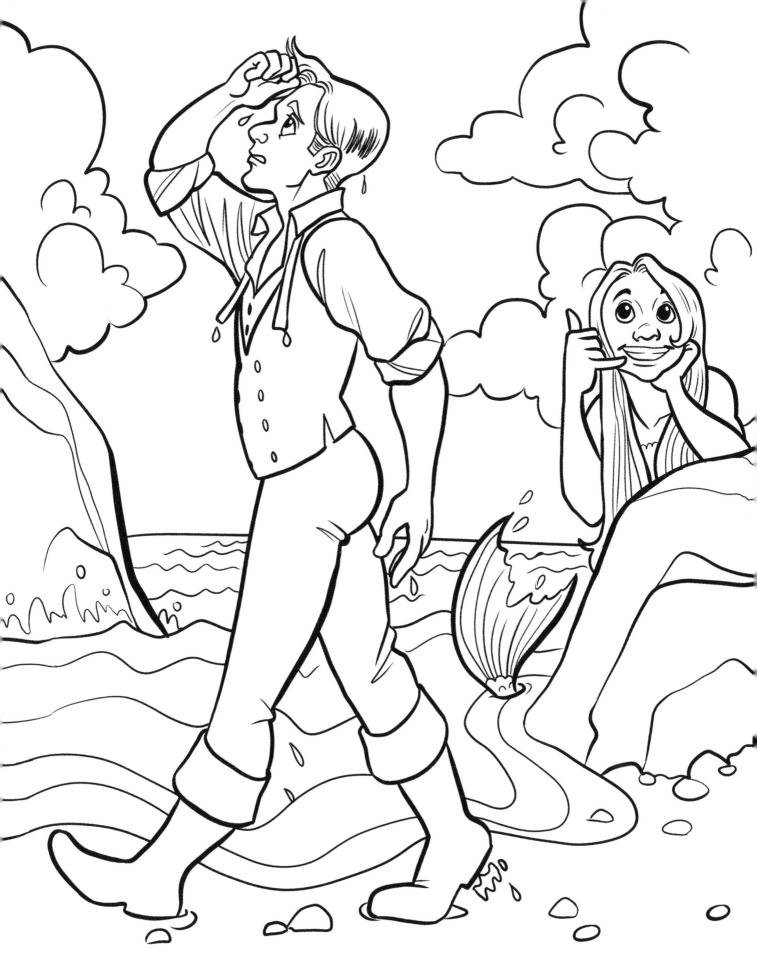

Human princes always expect you to save them,
but they never thank you.

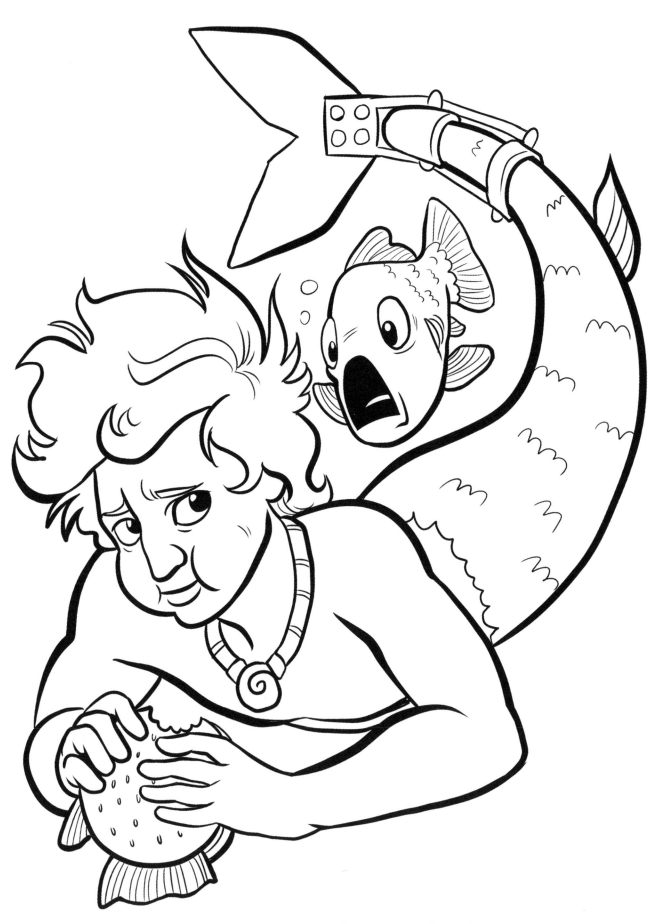

Fish are friends AND food.
It gets awkward.

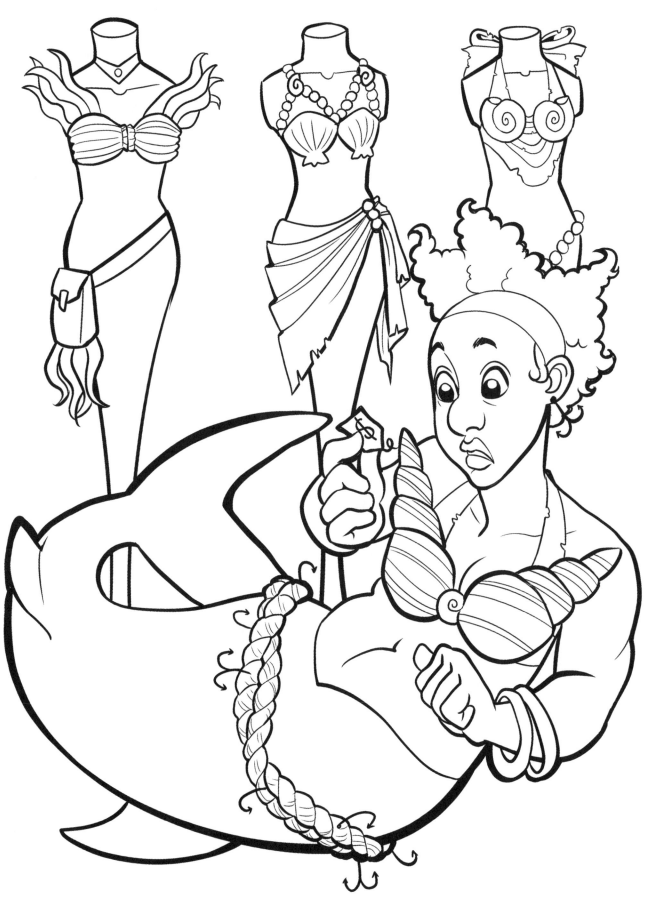

Keeping up with the latest fashion
in seashells is expensive.

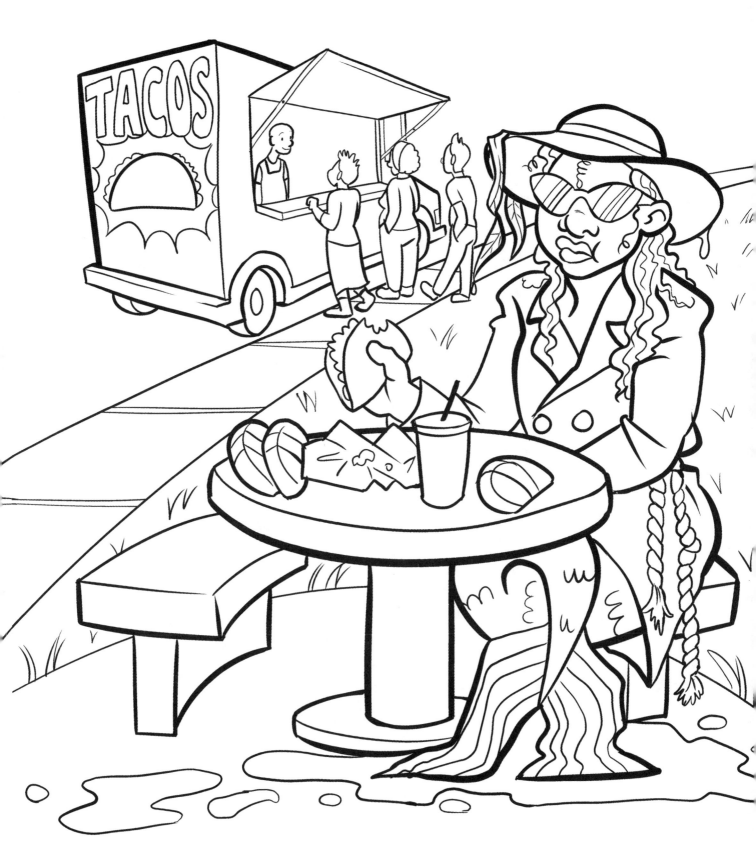

You have to leave the sea kingdom to get tacos.

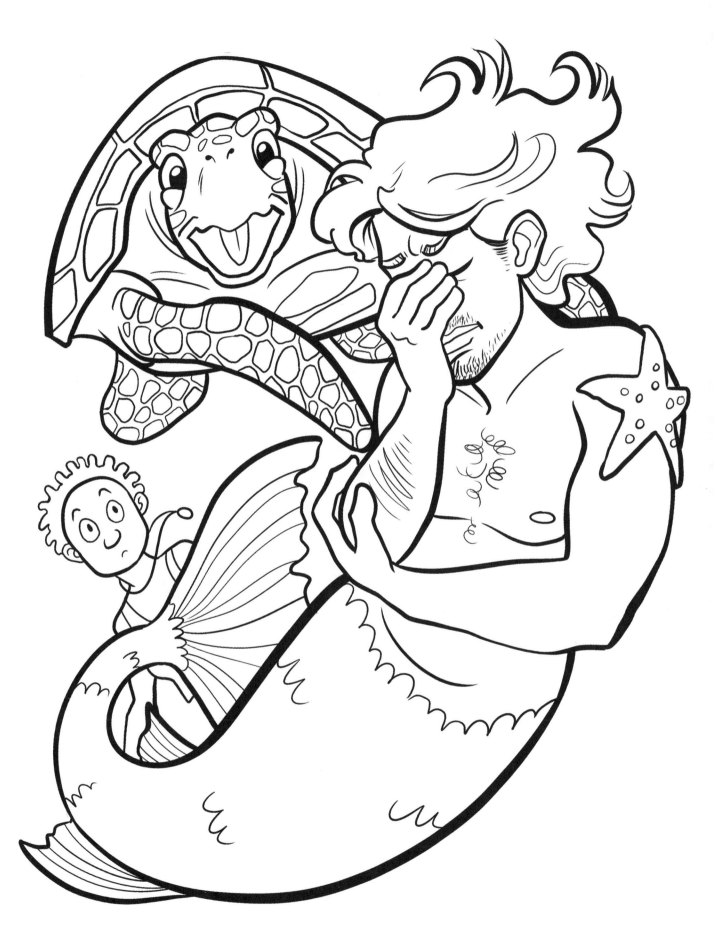

Sea turtles don't have boundaries.

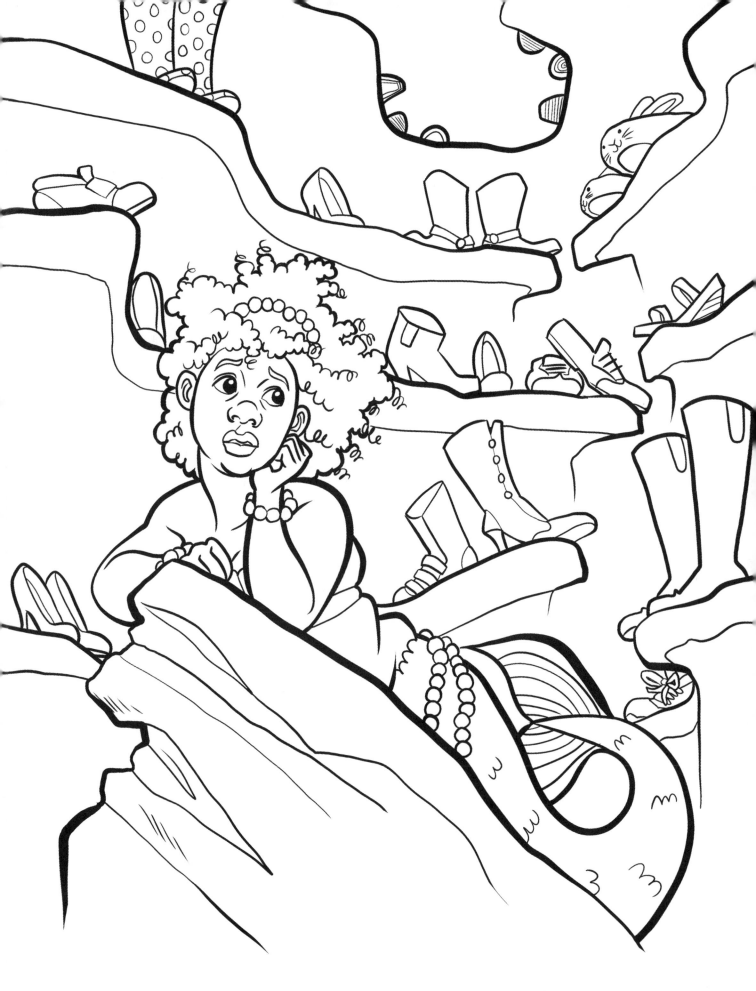

Legs are required for all of this season's cute shoes.

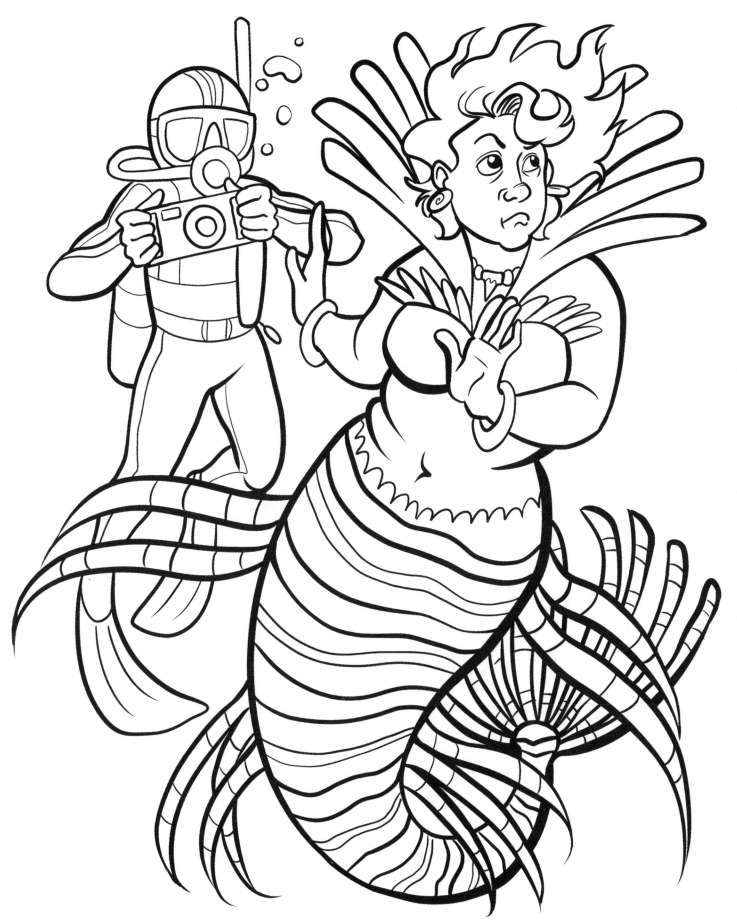

Tourists.

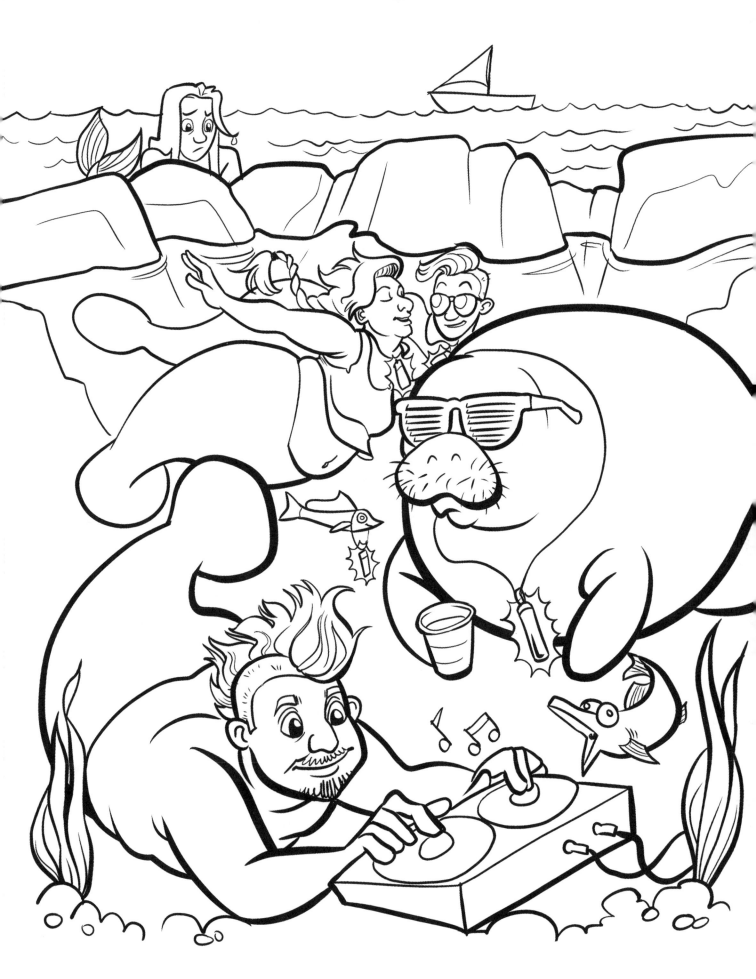

All the best parties happen in freshwater.

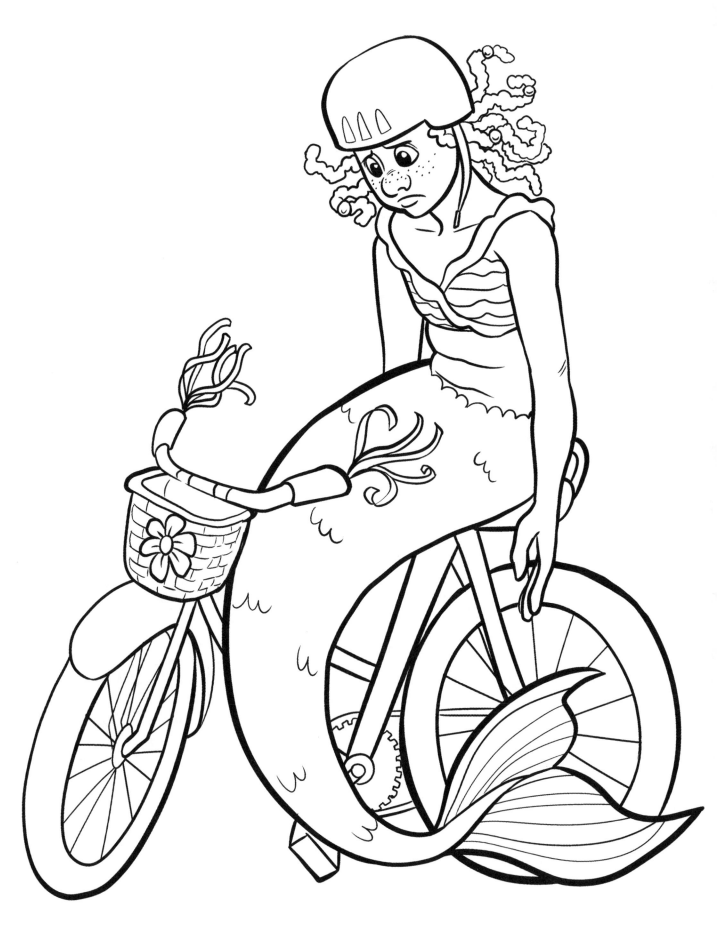

Bicycles weren't made for fins.

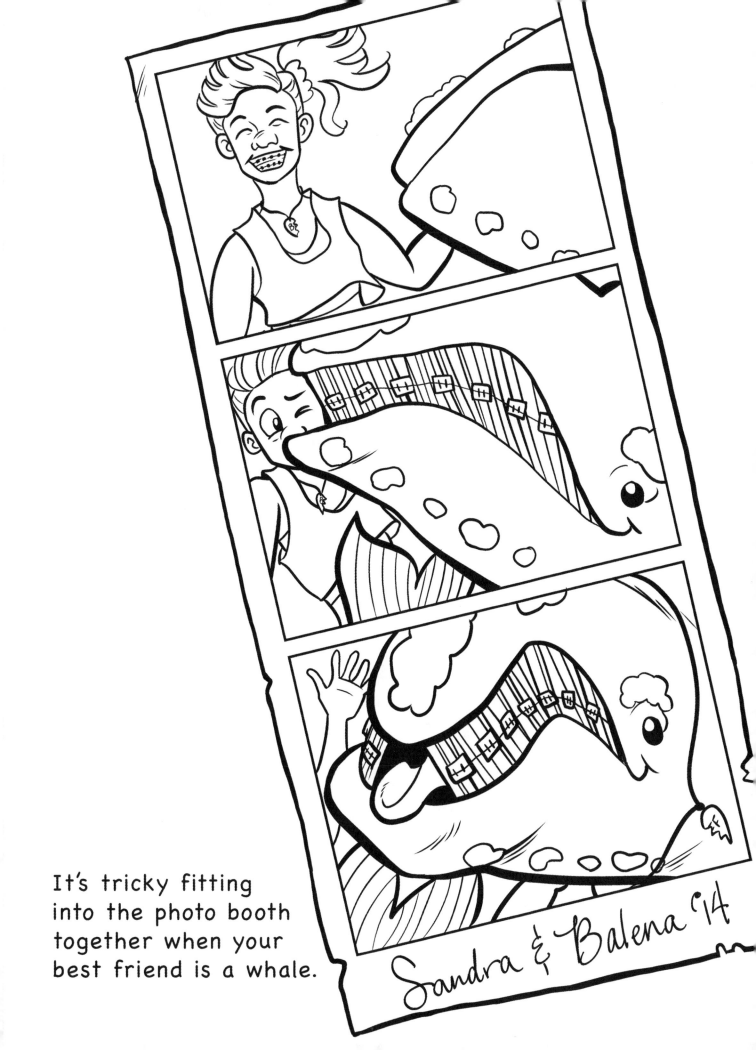

It's tricky fitting into the photo booth together when your best friend is a whale.

Sandra & Balena '14

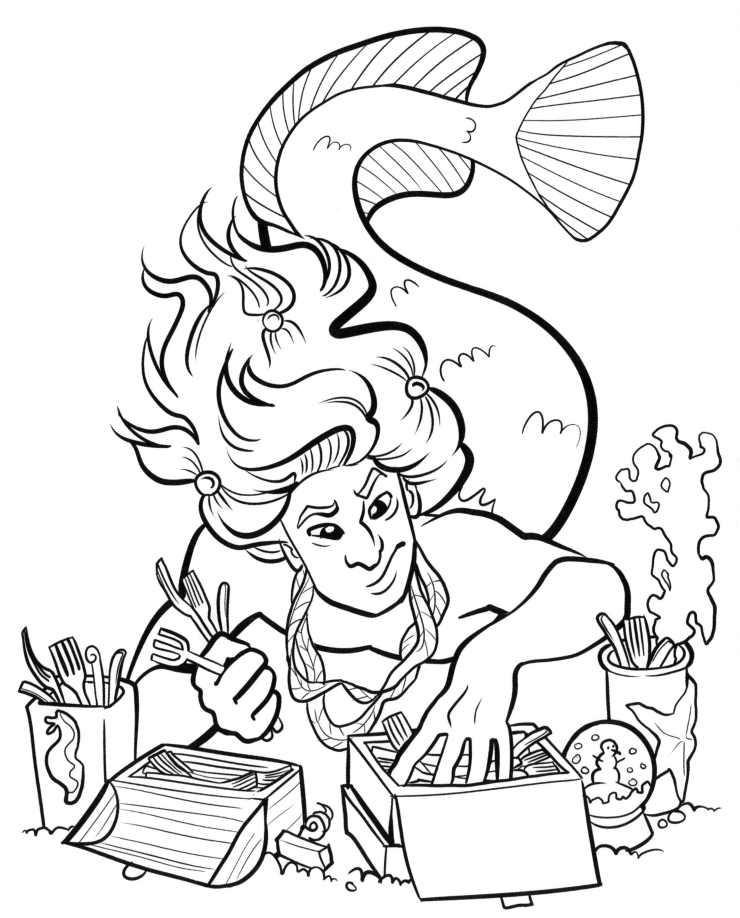

Never enough thingamabobs,
too many dinglehoppers.

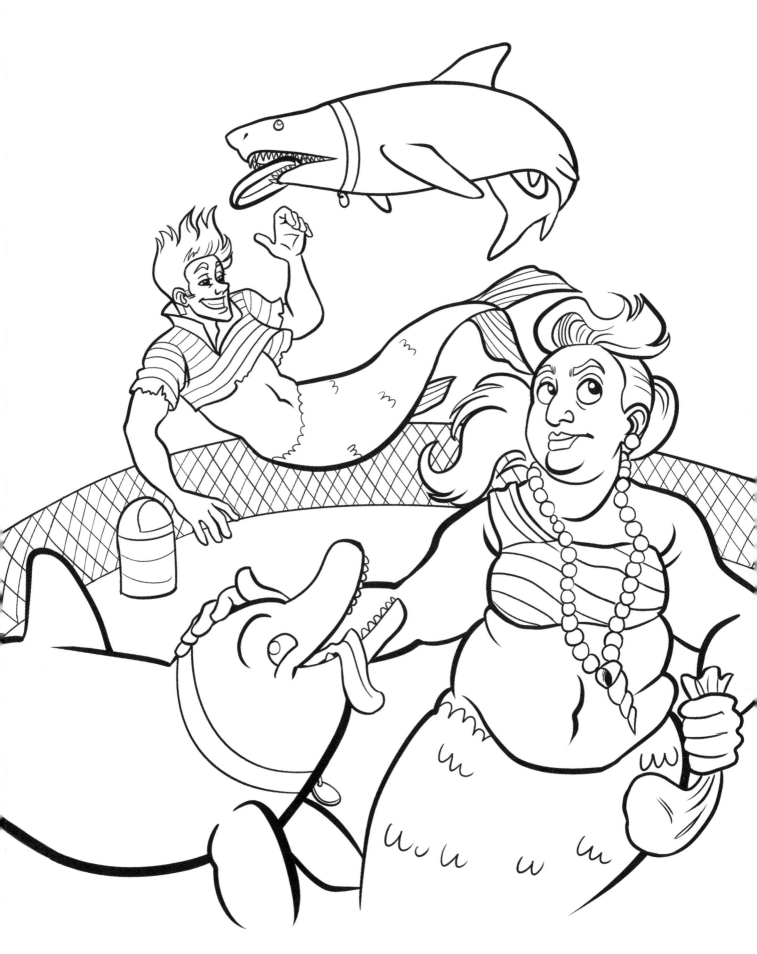

There's always that one guy
who brings a shark to the dolphin park.

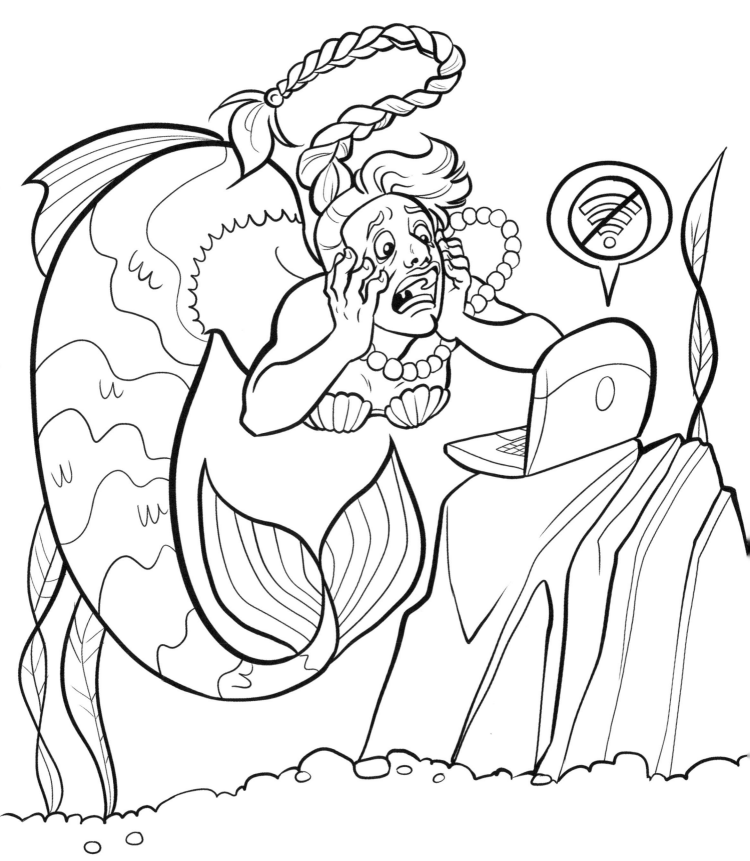

Under the sea, there's no Wi-Fi.

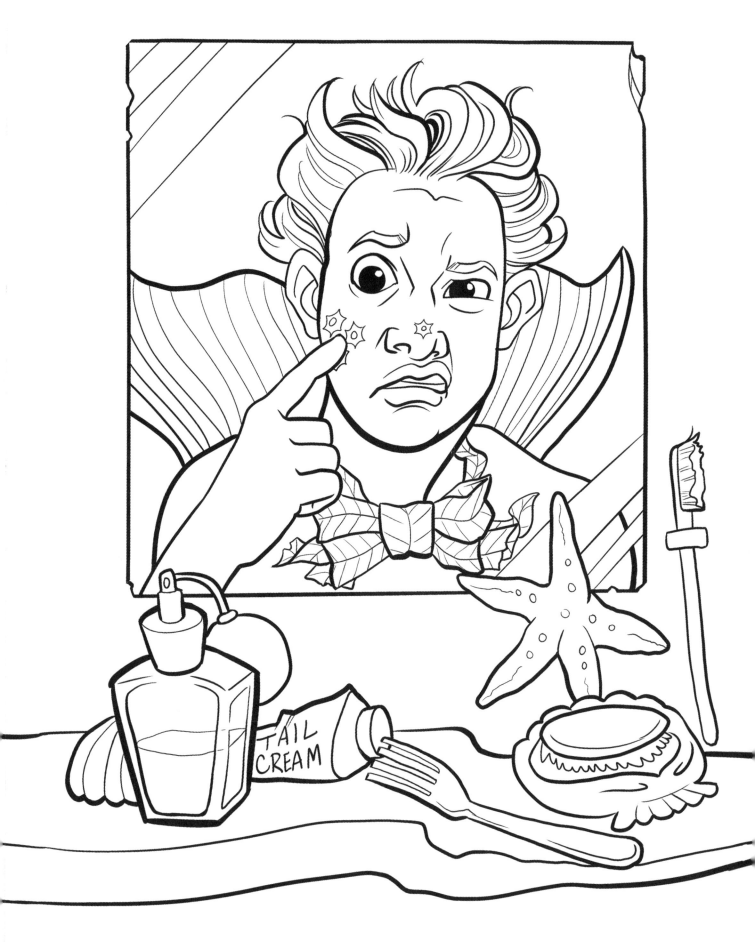

Barnacles always show up right before a first date.

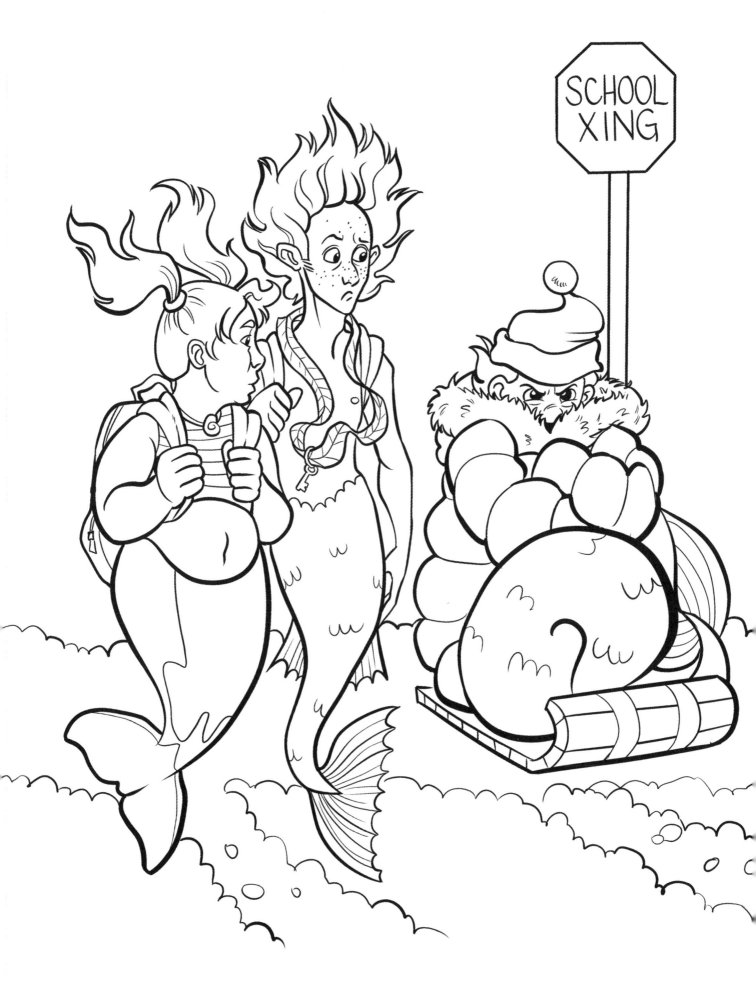

Merkids never get snow days.

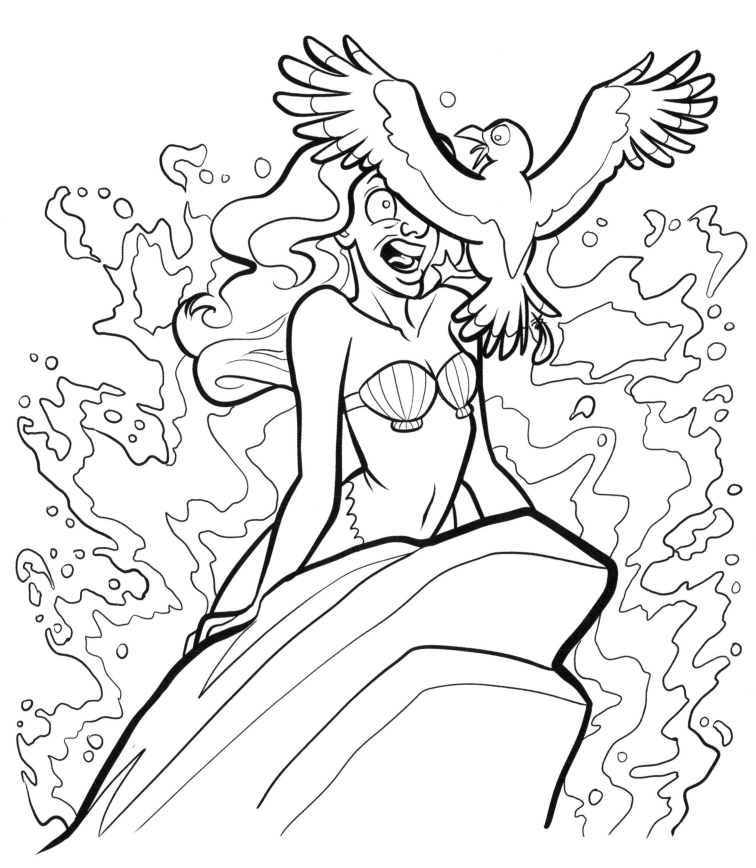

Low-flying seagulls can interrupt dramatic moments.

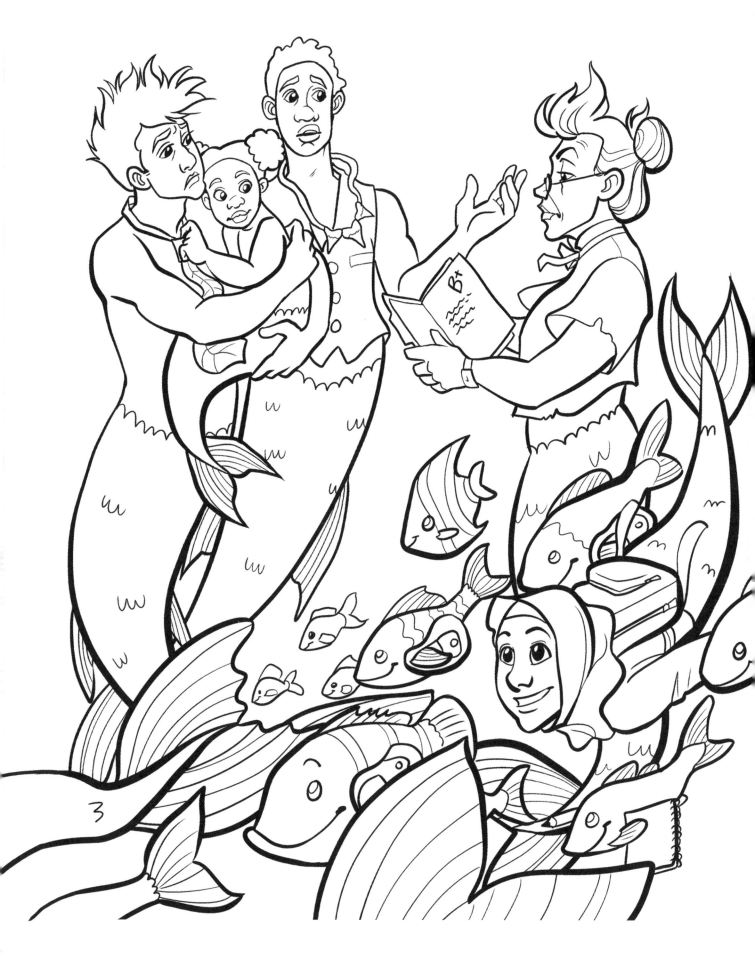

It's so hard to get into good schools these days.

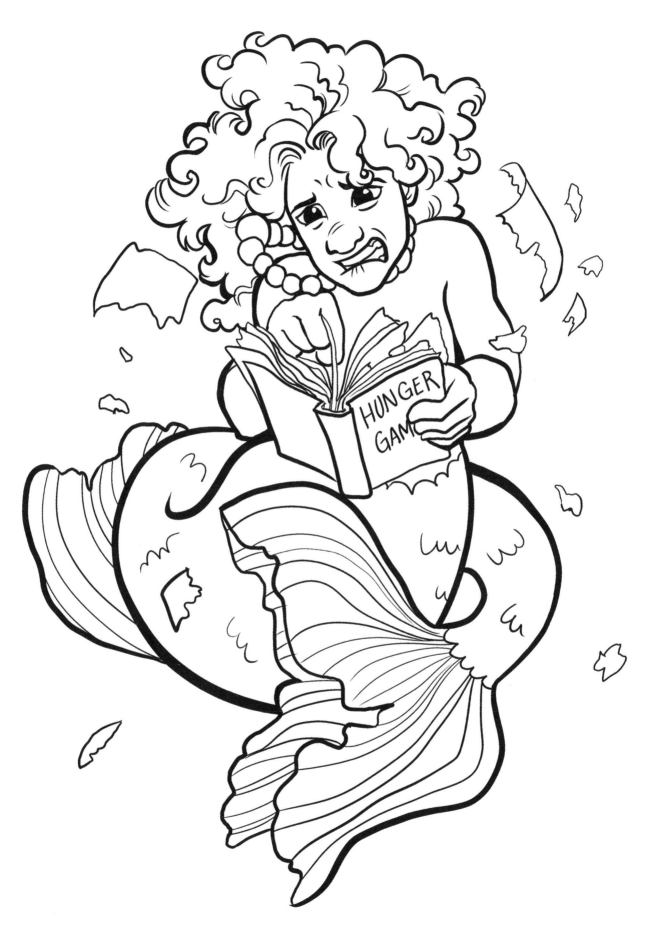

Books fall apart before you get to the end.

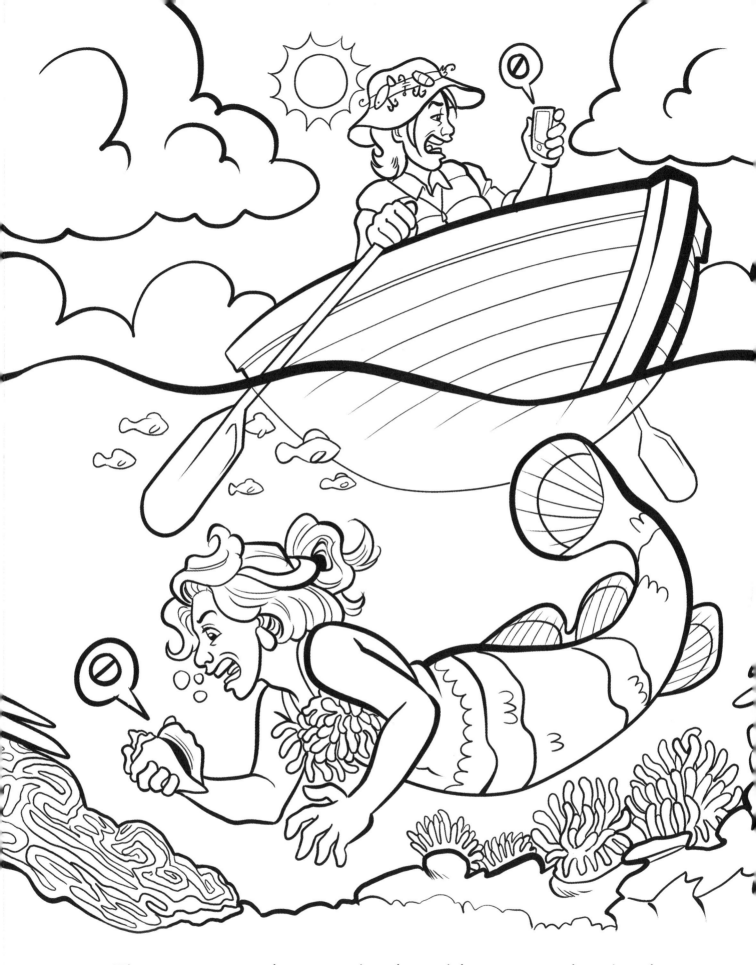

Those poor suckers on land could never understand
the problems mermaids have to deal with.

About the Artist

Theo Nicole Lorenz was born in 1985, weighing only six pounds and yelling a lot. Now many pounds larger and holding an MFA in writing from Hamline University, Theo still yells a lot, though mostly at the internet. Theo makes coloring books and sometimes comics in St. Paul, Minnesota.

For more of Theo's work, check out *Fat Ladies in Spaaaaace: a body-positive coloring book*. There's also art and things at www.theonicole.com.

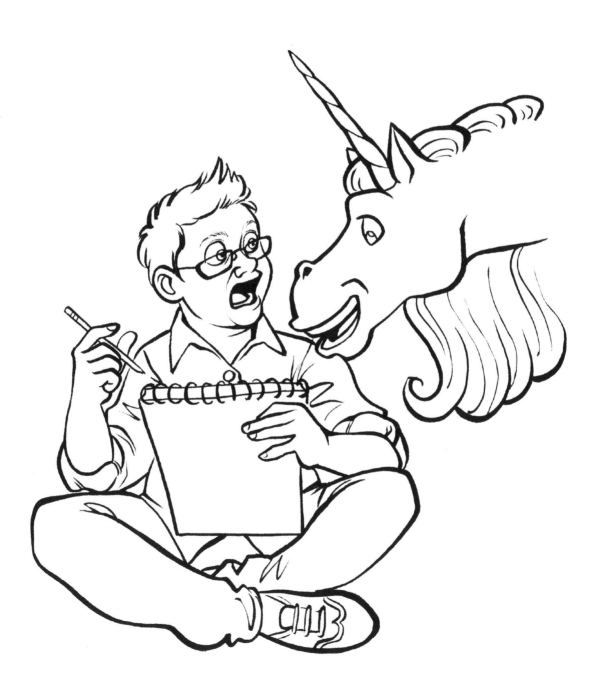